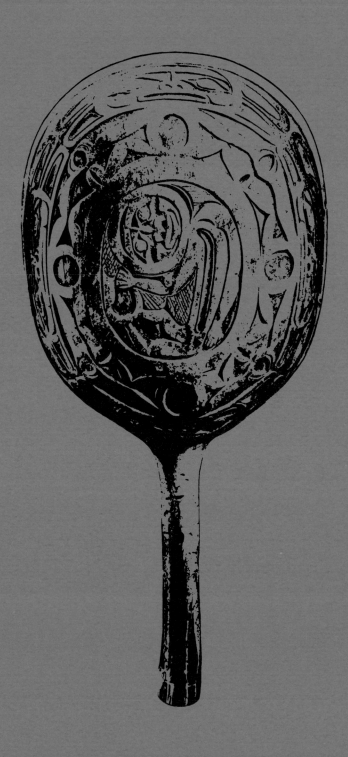

Cover: Button Blanket of Chief Minesqu' of the Nishga Village, Gitlaxdamix.

End paper: Rattle belonging to Chief Minesqu'.

Robes of Power: Totem Poles on Cloth

Copyright © 1986 Kitanmax Northwest Coast Indian Arts Society
All rights reserved

This book has been published with the assistance of the Canada Council

Royalties from the sale of this book will be donated to 'Ksan Publications for future
research and publication of Indian books.

Canadian Cataloguing in Publication Data

Jensen, Doreen, 1933-
 Robes of Power

 (Museum note, ISSN 0228-2364 ; no. 17)
 Bibliography: p. 83
 ISBN 0-7748-0264-2

 1. Indians of North America—Northwest Coast of North America—
Costume and adornment. 2. Indians of North America—Northwest Coast of
North America—Rites and ceremonies. 3. Indians of North America— Northwest
Coast of North America—Art. I. Sargent, Polly, 1913-
II. University of British Columbia. Museum of Anthropology. III. Title.
IV. Series: Museum note (University of British Columbia. Museum of Anthropology);
no. 17.
E78.N78J45 1986 646'.3'08997 C86-091540-9

Museum Note Editor: Michael M. Ames

Photography: Alexis MacDonald and Milton McDougal

Museum Note Design: W. McLennan **Printed in Canada**

Robes of Power

Totem Poles on Cloth

Doreen Jensen and Polly Sargent

Chief researcher: Jean McLaughlin

Foreword by Michael M. Ames

Museum Note No. 17

The University of British Columbia Press

in association with

the UBC Museum of Anthropology

Vancouver

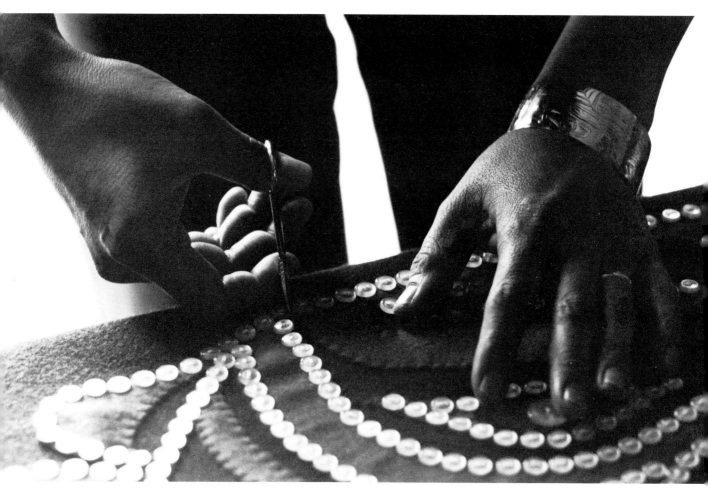

Figure 1.

Dedication

As the masterpiece of human life is created by man and woman
so are button blankets made.
As thread links materials to create beautiful and useful objects
so do button blankets link
past and present to create living records.
As the cycle of life is maintained by co-operation,
nurturing, order, and respect
so do button blankets maintain
our way.

Makers of Robes, past, present, and in times to come, our
honour and respect for your work to ensure that our culture will
continue to flourish, as all living things must.

The format of this book is an example of past traditions brought forward
to the present. The titles, "Requests," "Responses," and "Results" echo
the format of the potlatch: "requests" being the invitation bearers, who
request the presence of guest witnesses at the potlatch; "responses"
being the potlatch itself, where all manner of business is carried out and
histories recorded in the memories of the witnesses; and "results" being
the responsibility of the witnesses to restate or "call" important names
and business and commit them to memory.

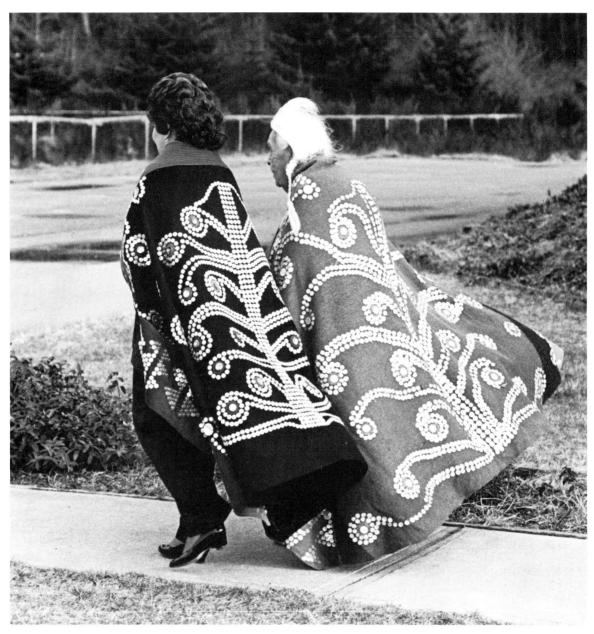

Figure 2. Louisa Assu and Agnes Alfred at the
Kwakiutl Museum, Cape Mudge.

Foreword

The power of art becomes powerful ideology when art is linked with social purpose. **Robes of Power**, as both book and exhibition, offers vivid proof of this connection. Ceremonial robes and their associated regalia have been among the most spectacular creations of the Indian people of the Northwest Coast of North America. For generations, these robes have served as insignia of family and clan histories, duties, rights, and privileges, and they are beginning to mark as well a determined presence in contemporary Canadian society. These robes are powerful statements of identity and, donning them, people become in a real sense what they wear.

Though Northwest Coast Indian societies have undergone many changes since Europeans arrived some two hundred years ago, ceremonial robes of status and power continue to be made and used. People still wish to display their historic rights and privileges, and they want increasingly to demonstrate a shared identity that is socially modern though remaining culturally Indian. The contemporary robes of power described in the following pages attest to these continuities and changes occurring on the Northwest Coast.

Before Europeans introduced manufactured cloth to the coast in the 1700s, the indigenous peoples made their ceremonial robes from animal skins and furs, especially those of the sea otter and mountain goat, and wove them from mountain-goat wool as well as cedar bark and other vegetable fibres. Designs may have been painted on the skins. When the northern tribes imported blankets, they adapted them to traditional forms by adding pearl buttons and abalone shell to outline figures drawn from their family and clan histories. This fastening of buttons—the origin of the term, "button blankets"—succeeded the older style of attaching amulets, puffin bills, dentalium shells, and greatly prized pieces of abalone shell to the robes. Such designs were also applied to shirts, dance aprons, and leggings.

The "button blankets," made typically from dark-blue wool with red-flannel appliqué and pearl-white buttons, were used increasingly from the latter part of the nineteenth century among the coastal Indian nations, from Vancouver Island north to the Alaska Panhandle: the Westcoast (Nootka), Kwagiutl, Heiltsuk (Bella Bella), Haida, Tsimshian, Gitksan, Nishga, and Tahltan/Tlingit. The only Northwest Coast groups that did not accept the button blanket were the Salish-speaking peoples of southwestern British Columbia and northwestern Washington State. They had their own style of robe, and a number of Salish artisans have in recent years recovered the traditional weaving techniques and designs of their area.

The robes discussed here were commissioned and brought together through the inspiration and initiative of the very remarkable Gitksan artist Doreen Jensen, who, as well as co-ordinating this book, curated the **Robes of Power** exhibition that appeared in six Australian cities before coming to the UBC Museum of Anthropology in March, 1986. Jensen's intentions were to show the strength of Indian traditions, record how Indian women and men work together in the creative act of making a robe, demonstrate how these ceremonial/political robes of power, with their bold patterns and bright colours, may also be viewed as works of art, and draw attention to the presence of separate Indian identities within the framework of the modern nation-state called Canada. It should also be mentioned that this is the first full-length study of the historical and contemporary use of this important ceremonial art form.

We hear from the blanket designers and makers themselves, in their own words, about a story that both reaches back into the mists of history and is poised to move dramatically forward into the future. We learn of the power and wisdom that people draw from their past and the elders of their communities. As the Kwagiutl artist Tony Hunt observes, he would feel incomplete making a speech without his button blanket. Once he puts one on, *It changes my feeling, and then I'm one hundred per cent confident with what I'm doing. I think about the responsibility that's placed on me. I feel a closeness with my ancestors. I feel a spiritual strength.*

The commentaries reflect differences in experience and custom from group to group and generation to generation. We learn how ceremonial robes are gaining acceptance (though not without controversy) as part of both educational and political activities, from school workshops on traditional Indian culture to courthouse demonstrations on behalf of native land claims. The button robe is thus becoming the appropriate costume for a resurgent "progressive tradition" of Indian ceremony and political drama. The songs, dances, and other customs that were "pushed under the rug" in response to European colonization, Dorothy Grant tells us, are being revived:

We, the elders of the future, are lifting that rug by once again instigating potlatches, songs, and dances based on our traditional roots, and, by the inspiration to keep tradition moving, creating new songs, dances, and rituals. Where once the button blankets were sitting in closets, they are now on the people...

The book concludes with "but one more question": who will take over where **Robes of Power** leaves off? The answer is suggested by the way this work itself was constituted: there will be many hands at work, both

Indian and non-Indian, searching in many directions, together and apart, and representing as many interests. Yet consensus is likely on at least the simple principle underlying this quest, the belief in the continuing importance—should one say "power"?—of tradition. It is customary in modern society to assume that to be progressive we must somehow transcend our past, either forgetting it or relegating it to dusty museums. This book contradicts that customary view by declaring, through the eloquent words and skilful deeds of those who make and wear ceremonial robes of power, that the past can continue to serve and guide the present in the form of "progressive traditions" that build towards a future.

The publication of this study would not have been possible without the generous support of a number of individuals and institutions. We are pleased to acknowledge the Canada Council's Explorations Programme; the Leon and Thea Koerner Foundation; the Government of Canada's Canada Works, External Affairs, Department of Indian Affairs, and Secretary of State; the Indian Arts and Crafts Society of British Columbia; the McLean Foundation; the Australia Council; the Adelaide Festival Centre; the Aboriginal Council; the 'Ksan Book Builders; the First Citizens' Fund; and Dr. George MacDonald, Director of the National Museum of Man, and Dr. Martine Reid, Department of Anthropology and Sociology, University of British Columbia, for their written contributions.

The Museum of Anthropology's participation in the production of the book and special exhibition was made possible by the Museum Assistance Programmes of the National Museums of Canada, the Government of British Columbia through the British Columbia Cultural Fund and Lottery Revenues, and by the special assistance of Finning Tractor & Equipment Company, Air Canada, Teck Corporation, and the British Columbia Telephone Company. We thank these agencies, and the many individuals who helped at every stage, for their assistance in bringing about this unique work. We are grateful to Dr. Margaret Hess for her support and commitment to the progressive traditions of the Indian people of the Northwest Coast. Special thanks go to the blanket makers and designers themselves, who generously shared their thoughts and their works.

Michael M. Ames
Director, Museum of Anthropology

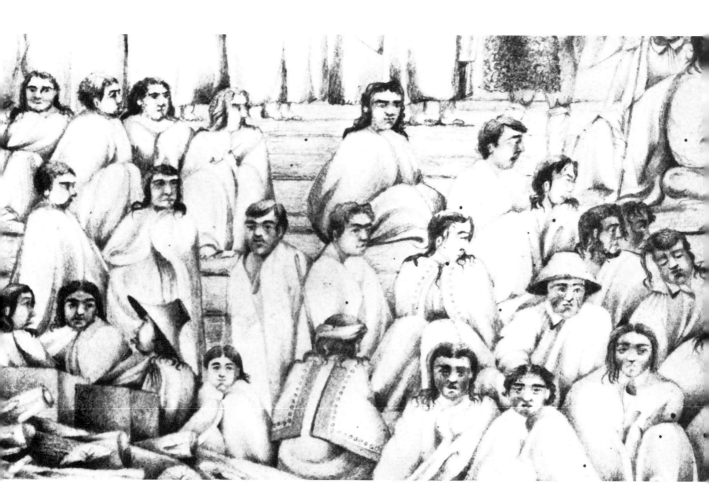

Figure 3. A drawing of the funeral of a Tlingit chief by Ilya G. Voznesenskii, cica 1844. Two people appear to be wearing button blankets.

Contents

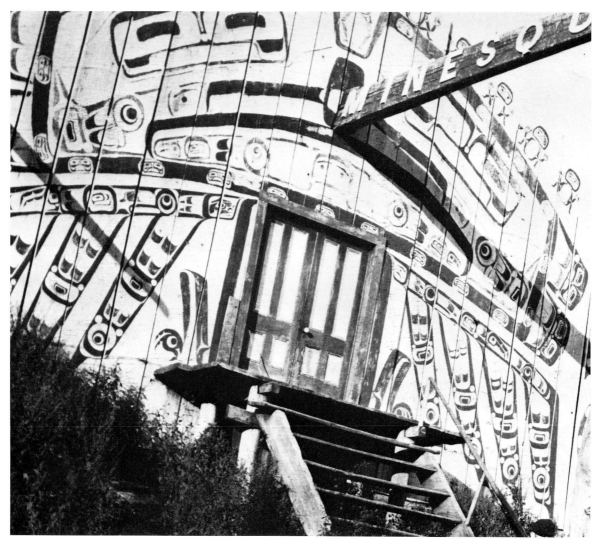

Figure 4. Painted housefront of Chief Minesqu'.

Preface

Robes of Power: Totem Poles on Cloth is an exhibition title that highlights a central feature of Northwest Coast Indian traditional art. Virtually everyone in Canada is familiar with the classic totem poles which once lined the Indian villages of the Northwest Coast. Those interested in native art have also learned to recognize the crest figures of beavers with huge teeth chewing on a branch, or bears with gnashing teeth and protruding tongues. However, as the field of the image changes from totem poles in rounded sculptural form to two-dimensional flat design, many viewers completely lose their frames of reference. The crests have dissolved into a confusing ebb and flow of unfamiliar formlines, even though the formal principles of two-dimensional Northwest Coast Indian art have been defined by Bill Holm. No one to date has defined the linkage between two- and three-dimensional art. The title of this exhibit throws primary attention on this 2-D/3-D relationship.

In my own writings, I have referred to blankets, both appliquéd button blankets and Chilkat woven blankets, as a very important step in understanding Northwest Coast Indian art (MacDonald 1983, 1984). I argued that dance blankets replicated housefronts, but they changed the dimensions of meaning by reversing them (the Chilkat blanket is an upside-down housefront) and changing the frame of reference from the social (the painted housefront) to the personal (articles of clothing).

I think everyone would agree that totem poles make the same statement as painted housefronts—that is, the social statement. The major change of focus is from the three-dimensionality of the carved pole to the two dimensions of the housefront painting.

The logic is much the same in the comparison of the dance blanket and the talking stick. They take the representation of power down to a personal rather than a social (or lineage) scale. The relation between social or personal and sacred is yet another dimension of the equation. Each step becomes progressively harder to follow. Fortunately, we occasionally find sets of artifacts that trace this sequence. One such set was collected from Chief Minesqu' of the village of Gitlaxdamix on the Nass River by Marius Barbeau of the National Museum of Canada. The blanket of Chief Minesqu' is very distinctive, as can be seen on the cover of this book (see also figure 5). It appears to represent a shaman flying through a round doorway (the sky door) with his hair streaming out behind him (a common visual device to show shamanic flight). On the outside of the circle are people joined hand to hand. This image is

duplicated across Canada in shamanic ceremonies whereby the shaman sits in the middle of a human circle. The humans define a doorway through which the shaman flies in his journeys to other worlds. The human group assists him to find his way back through the doorway on his return.

The Minesqu' set also includes his painted housefront (figure 4). In this example, the central figure is bracketed by birds. A figure emerges through a portal composed of similar figures, implying a mission to another world on behalf of the group and supported by the group. The blanket makes the same statement on the personal scale. Another example (end paper) depicts a shaman's rattle belonging to Menisqu' which repeats the same motif. The blanket is clearly the two-dimensional intermediary piece between these different fields of meaning. It is also an intermediary statement in an equation which begins and ends in three-dimensional carving.

This example is seen in many other sets of regalia and paraphernalia in Northwest Coast collections. It is interesting to note that the blanket was intermediary in another sense: it was made by women, while the housefront painting and the rattle were produced by men.

Reconstructing the equation that links Northwest Coast Indian art to meaningful statements is a major factor attracting scholars to the field. Each beautifully conceived object is a statement about their world. When they are taken together as sets, further meanings become apparent. Button blankets are a legitimate and unique form of narrative text about Northwest Coast Indian culture. A thorough study of museum and personal collections of button blankets, then, is clearly the next step.

Robes of Power: Totem Poles on Cloth is a valuable study of the survival of this visual narrative tradition and will, I am sure, mark the starting-point of a long journey of exploration into this unique art form.

George F. MacDonald
Director, Canadian Museum of Civilization, Ottawa

Requests

On the cover is a photograph of a traditional ceremonial button robe (also figure 5). Eye-catching; prestigious; costly. A coded legal document, decipherable by those who understand the art and traditions of certain Indian peoples of the Northwest Coast of North America and inland on the Nass and Skeena rivers. A robe of power.

The traditional, crest-style button blanket is the sister of the totem pole and, like the pole, proclaims hereditary rights, obligations, and powers. Unlike the pole, about which countless books and papers have been published, the button robe has no chroniclers. The button robe is the Cinderella of Northwest Coast Indian art, and would have remained hidden long past midnight had it not been for a perceptive woman, Silver Harris, exhibitions manager for the prestigious Adelaide Festival Centre. Silver grasped the robe's stature and requested an exhibition of the stunning garments for an Australian tour, which was supported by the Australia Council.

Figure 5. Button blanket of Chief Minesqu'.

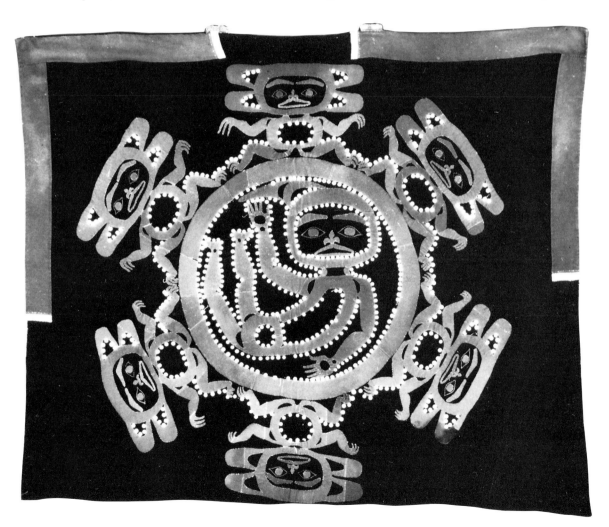

Request fostered request. Excitement about the proposal's possibilities won sponsorship from the Indian Arts and Crafts Society of British Columbia. The society's wholehearted enthusiasm provided the assurance to forge ahead with even greater confidence—and further requests.

Ancient blankets were too fragile and valuable to tour, and some owners of ceremonial button blankets did not want their regalia to travel outside the prescribed ceremonies. New robes had to be made. Twenty-five invitations to create new blankets were then directed to blanket makers from eight Indian nations. Twenty blanket makers accepted the challenge.

The lack of printed information about ceremonial button robes was soon evident. There were four and a half lines in Drucker's *Indians of the Northwest Coast;* a bit more than a page in deLaguna's three-volume *Under Mount Saint Elias.* Erna Gunther did a bit better but, when most libraries had been explored, there was still little of consequence. The obvious solution was to create something of consequence. Letters went out asking for funds to pay researchers, writers, historians—all the people needed to put together the first publication dealing specifically with button blankets.

Obviously, putting the book together would not be child's play. All sorts of capable people would have to be involved. We solicited support and active assistance far and wide. Heartwarming promises of participation came from George MacDonald, Michael Ames, Bill Holm, the University of British Columbia Press, and the Book Builders of 'Ksan. The blanket makers agreed to put their knowledge on tape, and other well-informed people promised to lend a hand.

Then, another type of request appeared on the scene. It came from the newly formed Publications Team and was addressed to its own members: list your ideas about the best ways to gather and present the information.

After lengthy discussions and a good deal of chopping and changing, the team came up with this short list:

— Tell it as it was told.
— Conduct the interviews in an unstructured way, taking to the "field" a mental list of questions, photographs of ancient blankets to stir memories, a small tape recorder, a photographer, an open mind.
— Concentrate on Canadian blankets: good work has already been done on the Tlingit.[1]
— Focus on the present, but glean all possible vestiges of the past.
— Give everything you've got to ensure that informants' opinions and personalities reach the reader. For the sake of clarity, taped information may be rearranged but never changed.
— Make sure that every informant has seen his or her material and is satisfied with its content.
— Learn everything you possibly can about button blankets before you begin the interviews. Comb the literature again and again. Consult all available authorities.
— Get a mental list of questions firmly in your head before you conduct a single interview.
— Be sure that the published material paints the blanket makers as the contemporary people they are.

With this short list, team members went off to find out more about button blankets. This book's **Responses** and **Results** sections tell of their findings.

[1] Otness, 1979

Responses : The Blanket Makers' Stories

Linda Bob, a Tahltan/Tlingit of the Wolf clan, was born in Telegraph Creek, B.C. in 1945.

Linda started working on blankets with her brother, Dempsey, in 1981. Dempsey designed the blankets and Linda sewed them. Linda also does beadwork on dresses, vests, and dance aprons which she designs and sews herself.

Linda and Dempsey started working together to replace the traditional regalia which had been sold to museums. They are making new regalia to be used at traditional ceremonies and feasts. They are researching their history and stories, and recording them on blankets.

Dempsey Bob is an artist living in Prince Rupert, B.C. He is of Tahltan/Tlingit descent, born in 1948 at Telegraph Creek in northern British Columbia. Dempsey started carving in 1969, and attended the Kitanmax School of Northwest Coast Indian Art in Hazelton in 1972 and 1974. He works in silver, gold, and wood.

Figure 6. Dempsey Bob with his sister, Linda (far right), his daughter Tanya (left front) and Linda's daughter Jackie Lyman, wearing their regalia.

His design sense is exceptional. He teaches wood carving, jewellery making, button-blanket designing, and related traditions and customs of his people. Dempsey's personal commitment to his heritage is inspirational.

Dempsey Bob *My grandmother's father was a carver. My grandmother's mother was a basket weaver. My grandmother and mother are artistic too, through their sewing and beadwork. My grandmother's uncle was a goldsmith, silversmith, and carver. This artistic tradition has been in my family. My grandmother says, "Teach your nephews, because we don't want to lose it." So that's what we are doing.*

I remember seeing button blankets in my grandpa's old photographs. He had many button blankets and Chilkat blankets. He had trunks full of regalia. He said, "How come people don't have any of these things any more?" My grandpa said that at one time, before they had cloth, they used to paint on moose skin and put fur trim on the border of the neckline. As soon as they got material and the buttons, they adapted them. The art evolved to the form of the button blankets.

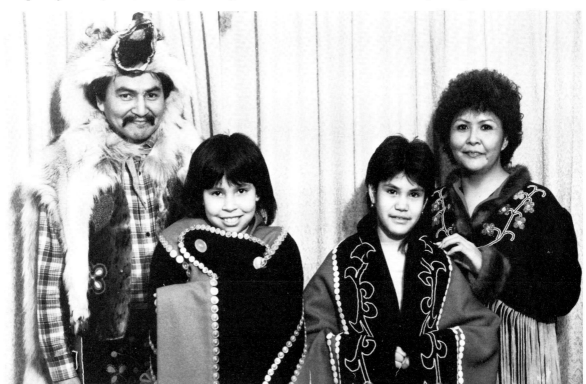

Our people say, when we wear our blankets, we show our face. We show who we are and where we come from. When we dance, we share part of our history with our people. It's more than just what you see when you look at a blanket. To us, it has so much meaning. The blankets become very personal.

Our people go to an artist and commission him to do a button blanket. They tell him a story, the artist draws a design, and if they approve of it, then they use it. The design becomes the property of the family and cannot be copied. Some blankets are passed down with names, our Indian names. To make the blanket have meaning, you have to know the history of the people and the crest designs.

In order to interpret the designs, you have to know the stories, yourself, your people, and nature. To be an artist, you have to know all those things. That is why our people say our designs and blankets are very special.

What I've done is gone back home and talked to a lot of elders and researched our history, button blankets, and designs, because that is what I teach. When I am teaching, I don't like to say that it's this way or that way, but that this is the way that I have learned it from my people. I've listened to stories my grandfather and grandmother used to tell. Some are written down, but many aren't. Many stories are kept within the families and will never be revealed or published.

I've used the story of Raven on the blanket I'm doing for Robes of Power. *It belongs to all of our people. Before there was any salmon, Raven got salmon eggs and dropped those eggs at the mouth of each river. After that, the salmon followed Raven back to where the people lived. Raven taught the people how to cook and smoke salmon. Raven gave us food to make life easier and better. The Raven story teaches our children to have respect for the salmon, and not to waste them. These stories we want remembered. There's an old saying, "When the Creek Mother sings, the salmon come."*

There's a story of Raven with the sun or the moon. I put it on one of my other blankets. Behind Raven is a circle representing the sun or the moon. I like the circle because our people say we live in a circle, and the circle represents our culture.

Besides buttons, people used to put abalone shell on the blankets. The abalone shell is a symbol of wealth and is reserved for the nobility. Abalone shell is placed on the chief's frontlets and rattles, too. The abalone buttons are valuable because they are laborious and time-consuming to make, and it was considered good luck to wear them.

It is more than just what we see when we look at a blanket. When we use things such as the masks and blankets, our art comes alive. It's not every day that we show our things but only on special days, when a totem pole is raised, or at a potlatch, or to cover the coffin of an important person, such as a chief. After the funeral the heir would be presented with the blanket.

Being a male, I can't pass on the family crests to my children, because the Tahltan descent is matrilineal. The women are the ones that pass on the crests to the children: they are the crest carriers.

Because our things have so much meaning for us, it is not right to show them off except on special occasions. The button blankets were stored in bentwood boxes. We made them for the potlatches. When we made things for people, we did our best. Everything that our people made was meant to be used, not just to be looked at. These things made us human.

When I decided to make this blanket for the Robes of Power *exhibit and knew that it was going to Australia, what I thought was, how are they going to understand? Our art has so much meaning to us, it is more than just what you see, it's what you know. It's real to our children, it's real to us. We have something very beautiful to share, and if it's art, it's art! If it's fine art, they will understand.*

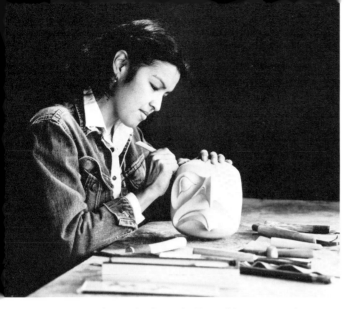

Figure 7. Dale Campbell working on mask.

Dale Campbell's Indian name is *Talth-tama*, which means, "Tahltan Indian Mother." She was born in Prince Rupert in 1954. She is a member of the Wolf clan. Dale's parents originate from Telegraph Creek, a small village on the Stikine River. She tries to visit relatives once a year at Telegraph Creek. She says, "It gives me an opportunity to hear the old Indian stories and stay in touch with the traditional lifestyles of my people." Dale's inspiration for her artwork stems from the myths and legends of the Tahltan and Tlingit people.

In 1972, Dale pursued Indian art with the encouragement of Dempsey Bob. She apprenticed with him for several years and later worked with native artists Glen Wood and Freda Diesing. In 1982, Dale, her brother Terry, and Alvin Adkins carved a thirty-foot totem pole for the Museum of Northern B.C. in Prince Rupert.

In the last few years, she has been able to make a living as a full-time carver. Many of the masks and plaques she carves have been commissioned by private collectors in Canada and the United States. As a teenager, Dale worked with crafts normally associated with the native woman's role in the arts. She says, "Once I started carving, it seemed that I had found a natural outlet for my creative energy."

Roy Henry Vickers was born in 1946 into a time of great change; he describes his personal experience growing through those years. His childhood was spent in small towns in British Columbia's north. His mother white, his father Indian, his own identity was often in question. He determined to explore his Tsimshian heritage when, still a teenager, he confronted the culture shock of city living in Victoria. He now operates a successful gallery in Tofino, where he carves and paints.

Roy seems comfortable with his choices. He manages his business, is active in community sports, and enjoys fishing from his boat in his spare time. True to Northwest Coast tradition, on his blanket he uses the crest granted his mother when she was "adopted" by the Kitkatla Eagle clan.

Roy Henry Vickers *I was born in the little village of Greenville on the Nass River in northern B.C. I was brought up in Kitkatla, Hazelton, and Victoria. My mother's parents came from England, while my father's parents are of Indian heritage. Before my mother married my father, Matthew Hill, the Eagle chief of Kitkatla, adopted her as his daughter, and she acquired the Eagle crest. This was an old Indian custom which gave my mother credibility and the crest of the Eagle. In the 1940s a white woman, a well-educated woman marrying an Indian man, was something that wasn't done. If it was, it wasn't done very often.*

My paternal grandfather came from Bella Bella and my paternal grandmother from Kitkatla. She came from a high-ranking family, and so did Henry Vickers, my grandfather. After marrying, they chose to live at Kitkatla. Her father, my great-grandfather, Amos Collinson, was a great artist and the Raven chief at Kitkatla. He had the "robe of power," a Chilkat blanket, and an amhalayt [chief's headdress].

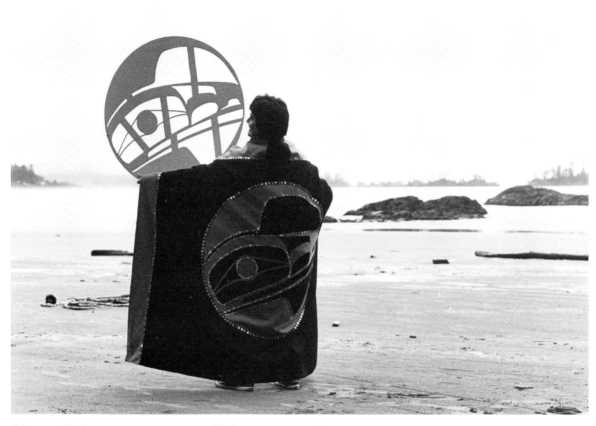

*My grandfather was a canoe carver. He intro-
duced me to carving at a young age, but I didn't
do any then. I actually didn't become involved
with art until I was sixteen. That was when I
started studying Northwest Coast art and doing
silkscreen prints in high school.*

*At about this time, my family moved to Victoria.
I felt lost because of the move and because I was
the only Indian at my school. I still had a
longing for the reserve and my childhood, say
when things were simpler. Being in the city
complicated my life, but it gave me a desire to
learn, and this desire is with me twenty years
later. I began to study Northwest Coast Indian art,
and this prompted me into the search for my
identity. I began to frequent the B.C. Provincial
Museum, and it was Wilson Duff at the museum
who was responsible for getting me interested in
Northwest Coast Indian art.*

Figure 8. Roy Henry Vickers holding design template.

*My first recollection of button blankets was at the
museum when I was sixteen years old. They were
on exhibit there. I looked at the wax statues of
these Indians wearing button blankets, and I
could feel their power. The power is there because
it is art and has something to say. The power
emanates from good artwork. The blankets that I
saw then had quite an influence on what I do
now, and how I think. I carved for about eight
years at the B.C. Provincial Museum on my own.
At the age of twenty-five, I decided to go to
Kitanmax School of Northwest Coast Indian Art,
leaving a very secure job. I was a professional
fire-fighter then. It was then that I began an
in-depth study of all the Northwest Coast Indian
culture—not just art, but dancing and singing.
That was the beginning of my formal learning of
the Northwest Coast Indian culture.*

I have designed three different button blankets. I helped do the cutouts for the appliqué, and I have actually sewn a few buttons on blankets, but when it comes to the stitching, that was done traditionally by the women of the village. There are women who are experienced at making the blankets and I like to carry on that tradition.

My first blanket was an Eagle, which of course is my crest. My second blanket was a circular moon, and it was made at a time when I was working in Vancouver and, unfortunately, I don't know where they are today. My third blanket is the Eagle done in a circle.

I have worked on different blanket designs, and I like the idea of an appliqué applied to a blanket. I like the idea of it being a whole piece, cut out of one piece of cloth and applied to a blanket. I like things to be bold and strong, but simple. To me, good appliqués on button blankets are that way.

One of the things that I am finding now is being titled "Indian artist." I would rather have people think of me as an artist who happens to be part Indian. The Northwest Coast Indian culture and art are obviously a very strong influence in my work, but I live today, and I have to find that balance in my artwork as well as in my life. If an artist who lived at the beginning of the 1900s could have lived long enough to go through that transition and lived with a foot in both worlds, I think he would be doing what I'm doing right now. I am getting the title now as innovator or someone who has broken away from traditions. I feel that what I am doing is traditional. I can live as an Indian artist where everybody looks at you as being an Indian, and as a person who lives in the big city, in the same society as other nationalities.

When I was first contacted about the button blanket for the exhibition, I was fairly busy with the gallery here, and I wasn't going to make one. One day, Art Helin and his wife, Carole, came to visit from Parksville. I discovered that Art was

originally from Port Simpson, which is near Kitkatla. His mother comes from Kitkatla, and his crest is the Raven. We have known each other most of our lives, and as we were discussing our family backgrounds, we realized that Art is actually related to my father. Carole said that if I designed our button blankets, she would sew them. There were two designs that I had been experimenting with for quite a while. I did little sketches and it seemed as if we were going to do twin blankets, one being an Eagle, which is my crest, another a Raven, Art's crest, and both done in circles. We got excited.

Carole Helin was born in Prince Rupert, B.C., of Scandinavian background, and raised there. She now lives in Parksville on Vancouver Island. She is related to Roy Vickers by marriage. Her offer to sew Roy's robe was all the encouragement he needed. In preparing for her work, Carole consulted many friends and visited libraries to learn more about the background of button blankets, which she had seen about her for most of her life. Through her efforts to learn the traditions, she has made a strong contribution to **Robes of Power.**

Carole Helin *We chose the red design on black material, as we wanted the blanket to appear big and bold. The border was left simple to accent the design, signifying power to the crest. Border designs are the expressions of the sewer; the design belongs to the artist-carver.*

The abalone-shell buttons look rich on a blanket and were the original buttons used long ago. It was also to show wealth in those days. The more buttons on a blanket, the more power your blanket had. In the light of the fire they had a special effect: the design would stand out, and look impressive.

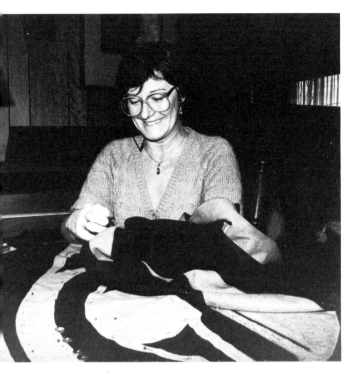

Figure 9. Carole Helin working on Roy Vickers' button robe.

Roy's family crest is the Eagle, so of course he chose to design the Eagle. He put the eye as the focal point, and the wings of the Eagle have been closed to represent strength. The entire bird is there. Our daughter, Leanne, learned and assisted me on the sewing of Roy's Eagle blanket.

My husband's mother, Maud Helin, a chief of the Gitgeese tribe of the Tsimshian Nation, was very involved with all her children. She talked about their culture and history and where they stood in the world. She never stopped telling them how important they were in society. I thank Roy Vickers for introducing me to such a beautiful ancient craft. It is a great honour to have done a blanket for a talented artist such as Roy.

Norman Tait has a clear understanding of protocol and potlatch law among the Nishga. He was born in 1941 on the Nass River and often accompanied his father fishing or watched him carve. Though he has lived in Alberta and now lives in Vancouver, he maintains close ties with family and friends of the Nass River. He researches in museums and consults with the old people of his area to master his Nishga traditions. He designed and sewed his robe, and plans to validate it at the feast for his Chicago pole. He holds a highly respected name of a hereditary chief for having carved and raised this totem pole. For many years, other heirs felt unworthy to receive the name: now it lives on in Norman.

Norman Tait *I was raised partly in Kincolith, but mostly off the reserve at the canneries. The elders were retired from the fishing business, and I would sit on the wharf at the cannery, listening to them talk. One of my favourite pastimes when I was young was to sit and listen to them tell stories. I still remember many of them today.*

My maternal uncle was the elder of the family, a leader, and he knew the social system of the Nishga. When he heard that I was going to raise a totem pole at Port Edward, he said, "It is our law, when you do something as honourable as raising a totem pole, you have to be covered with a button blanket and you have to be proud of who you are. To do that, you have to come out with a button blanket or something to show which tribe or family you belong to." The pole I raised had an Eagle on the top and a Beaver on the bottom. My crest is the Eagle, so he told me to put an Eagle on my back and show the people. My uncle died five years ago.

When it came time to have a potlatch for the pole, I still did not have a name, so my father told the people that I must be given one. There was a lot of dispute and excuse-making, and finally my father threatened to adopt me into his tribe so that I could get a Wolf name. The dispute was caused

from the people not knowing if they had the right to choose the name or to give the name, until my uncle stepped forward and said he knew where the family line went. They knew the name, but did not know if they had the right to give it, or if I had the right to it. So my uncle confirmed it. My name had to be acknowledged at a potlatch, and several tribes came forward and called my name. The more people that call your name, the more solid your name is. The name entitles me to use a ceremonial button blanket with the crest on it. Since then, I have received other names, and with each one I am entitled to another button blanket, although I only have one, which I use for all purposes. If you had more than one blanket, not more than one was ever taken out on a specific occasion. They were put away and, at an appropriate time, another one could be taken out. Sometimes, only one blanket would be used throughout a lifetime, and sometimes it rotates, depending on the circumstances.

When I got my blanket, I received the name Na-ax-lax, *which is a young boy's name and given to a boy waiting his turn in line. I passed this name on to my brother, and in this case, since it is still in the family, my brother made his own blanket, and I was able to keep mine.*

My name Na-ax-lax *goes with my first blanket now, and for my other name,* Kwakw, *I should have another blanket. They both come from different branches of my mother's family. They come from two houses. If they ask me to pass on one of my names, my blanket goes with it unless it goes to my brother. Whoever gets that name, I would step forward and hand over the blanket to the families who are calling, and they would wrap him with it. The blanket is like a contract, a title or a deed. It goes with the trapline and whatever else there is. If one is next in line to be house leader, the house goes with it too. A lot of things go with it, but the main thing is the blanket.*

We raised a totem pole in Chicago at the Field Museum in 1983. We have not given a feast for the pole yet, but things are gathering. I was given a new name, Na wotxw Lik'insxws Lax Gal Ts'ap, *which means, "Grizzly bear coming into the village." That name is because of the pole, and the Eagle tribe (my tribe) is brought up one step again. Because of the pole, all of the Nass River recognizes what I have done. My grandfather said that I deserved the name, which was dormant for a long time. It was a hereditary chief's name, and actually belonged to another carver of our people. The carver received his name when he was a young man because of his career as a carver, being an artist and a doer. His name became so powerful that people refused the name along the way because they could not uphold it. When I came along and started doing the same things he did, they decided the name should go to me.*

This blanket I'm making for the exhibition is an offshoot of the totem pole standing in Chicago. This is the second blanket I've designed. It is the spirit of the Beaver in human form. It has human hands and animalistic feet. It doesn't have a tail, and it has two front teeth. What you see on this blanket is a little man who still has beaver teeth. The five coppers on the border represent the five brothers. This is what the totem pole in Chicago is all about. You might say I am entitled to wear this blanket because of the pole I raised in Chicago.

It is interesting the way that the blanket came together. I always shop around in second-hand stores looking for unusual tools that I could use. Old tools are the best. Gerry Marks and I were in Seattle, and on our way home we stopped off at a second-hand store, where we both spotted jars and jars of old buttons. We got something like four quart jars of buttons for something like six dollars. I stood there for a long time, testing them. I just couldn't believe it. The buttons were of a different age, the red material for the border is new, and the dark cloth I bought some time ago. I knew I

was going to make a blanket, but I didn't know when and was not really pushing it. I have been carrying it around, not knowing when I was going to use it.

This blanket took years to come together, piece by piece. I knew it was going to happen sooner or later. It was getting ready. The design I made when I was living on Bowen Island. I was offered so many times for its use for different things, and there again I did not use it. But then, here it is on the same blanket that took so long to come together. One of the first things that hit my mind was that this button blanket has been planned. It sort of goes with my grandfather's teaching and his talks with me. The red borders on the blanket represent life, new life. The black or dark blue represents death.

On the Nass, there is a story of how the valley became wiped out in a flood because of misdeeds against the people of the forest and people of the water. The Spirit came down from the mountain and told this old man to help his people by doing something to straighten them out or by teaching them. They didn't want them just to go and fish for the fun of fishing or hunting. At the time, the fish and animals were plentiful. He spoke to his people and nothing happened. They just shunned him and said that he was getting old and jealous because he couldn't hunt any more. This went on and on. Finally, the Spirit decided he couldn't wait any longer. He wanted to renew the land and start all over. So he flooded the whole area. He flooded the Nass Valley and wiped out the population except for three women: an elderly lady and her two granddaughters who were coming into puberty. They were in a cave high up in the mountains, going through the ritual of becoming women. When they returned to the Nass Valley, the flood was over. The elderly lady realized what had happened because she remembered the old man speaking about it earlier. Because they were the only ones left, they became sole owners of the valley. She gave her two granddaughters

chieftain names, and today the names are still passed on.

That was the beginning of women becoming chiefs in the valley. She said that the valley had to stay alive, so she sent her two granddaughters out to find men and bring them back into the valley to start all over again. When the valley became populated again, two colours came into being—the dark blue and the red. These colours were to remind the people that the same thing could happen again. They should always look after the land, because the land was not theirs, but on loan to them. So they started to use red borders on the robes, which meant new life on the Nass River, and the dark background is to remind them that what happened then could happen again. This is an ancient story.

The totem pole at the Field Museum in Chicago and this button blanket, "Spirit of Beaver in Human Form," tell this story. It is the story of the beaver and the little boy who found it many generations ago. Five brothers of the Eagle clan decided to give a winter potlatch, so they set out to get beavers, one of the forms of money in those days. The hunters leave the youngest brother on a hill to count the beavers, then they start to kill them. As the beavers panic, he notices two little ones escaping. He follows as they make their way upstream and when they have trouble getting over some waterfalls, he helps them. They run to another beaver lodge and disappear inside. He peeks into the lodge through a smokehole on the top. Why should there be a smokehole on a beaver lodge? Inside the lodge, he is surprised to see the old chief sitting at the head. The two little beavers are undressing, and they are really human beings, children of the chief of the Beaver clan. The children go to him in the lodge, sit on his lap, and tell him about the slaughter. He sings a song of mourning. Then they all dance the freezing dance to freeze the water on the pond so the hunters cannot kill any more. The young hunter sees all this, and is saddened. He notices a

large totem pole standing beside the Beaver chief which consists of many carved beavers and was called the Big Beaver pole. The hunter decided to adopt this pole as his crest. He returned to his brothers and told them what he had seen. They too became sorry they killed so many beavers. To show their respect for the dead, they adopted the songs and dance of the Beaver people.

My father always drummed into me that it was such a shame for a prince or princess not to be identified. They were given blankets and asked to stand among the already made chiefs and the ladies of the chiefs. Some of them got their blankets at birth, because their names were so important in the family and some of them had to have it.

A ceremonial apron is decorated with designs, and in the old days, when they gave a feast, they gave blank aprons away to the ladies. It is called ts'he-nak-in. *That means "over the dress." If someone is doing something important for you, you pay them and a certain part of the feast is called* nak-in. *This is when they start giving*

out aprons and that is the most important part of the feast. They also give out other stuff like guns, other gifts, blankets, and more blankets.

I would like to make a work jacket, too. You wear it while you are handling the totem pole, handling people, or getting ready for a potlatch. When you get ready for a feast, that is what you would wear. When the main ceremony comes along, you take off the jacket and wear the button blanket.

A lot of people are wearing button blankets and wearing them at the wrong times. They are not really understanding them. They used to have someone carry the button blanket and look after it, be the guardian of it. You don't wear it all the time. I realize the importance of button blankets, and I wasn't really sure whether anyone was interested in it, so I just kept it to myself. I had a quiet respect for them. I knew that my grandfather, and especially my uncle, had a deep respect for the button blankets too.

Figure 10. Norman Tait sewing crest on robe.

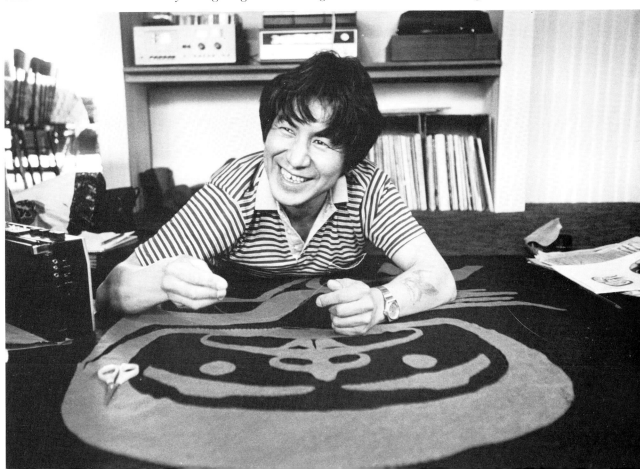

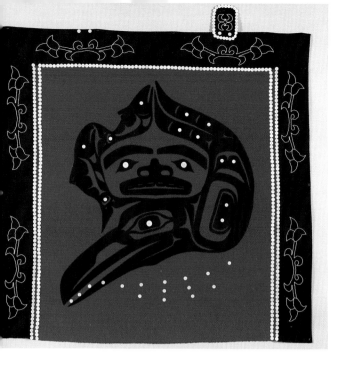

"When we use [wear] the blankets, our art comes alive. It's real to our children, it's real to us. We have something very beautiful to share... our people say, 'We carved things and made things beautiful because life was tough. It was hard, but these things made us human.' "
Dempsey Bob, 1985

Plate I

Designed by Dempsey Bob (Tahltan/Tlingit), 1985

Sewn by Linda Bob (Tahltan/Tlingit), 1985

Red and navy wool,
pearl buttons with beadwork on border

This design from the Raven cycle of Northwest Coast histories shows Raven scattering salmon eggs along the British Columbia coast.

"I learned a lot from my grandmother. It's amazing how much they [the elders] know, and they make you value things in your life a lot more." Dale Campbell, 1982

Plate II

Designed by Dale Campbell (Tahltan/Tlingit), 1985

Sewn by Dale Campbell, Lena Perssons, and Peggy Campbell (Dale's mother)

Red melton cloth, black border and appliqué, plastic buttons

The design is the Dogfish.

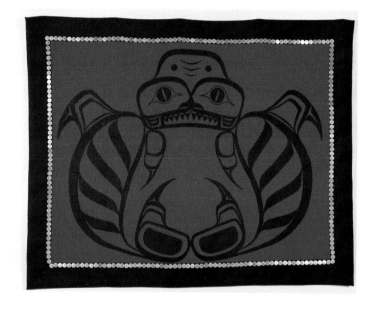

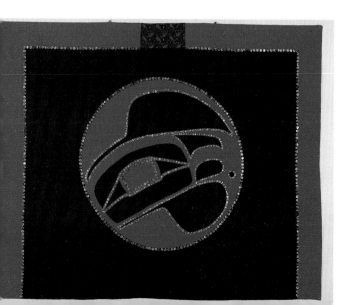

"My first recollection of button blankets was at the museum.... I could feel their power. The power is there because it is art and has something to say." Roy Henry Vickers, 1985

Plate III

Designed by Roy Henry Vickers (Tsimshian), 1985
Sewn by Carole Helin
Navy and red wool, abalone shell buttons
The design is the Eagle, Roy's crest.

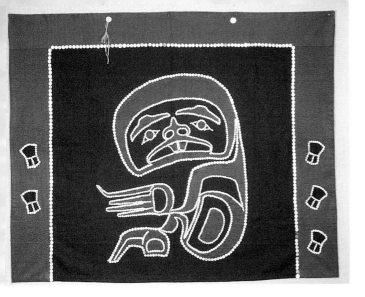

"It is our law, when you do something as honourable as raising a totem pole, you have to be covered with a button blanket and you have to be proud of who you are." Norman Tait's uncle, quoted by Norman, 1985

Plate IV
Designed and sewn by Norman Tait (Nishga), 1985
Navy cloth red borders and appliqué,
old mother-of-pearl buttons
The design is the spirit of the Beaver in human form.

"This design was inspired by my mother's reminis-cence of olden days." Margaret Heit, 1985

Plate V
Designed by Chuck Heit (Gitksan), 1985
Sewn by Margaret Heit (Gitksan)
Navy wool cloth, red appliqué, pearl buttons
The design is two Killerwhales and is a family crest.

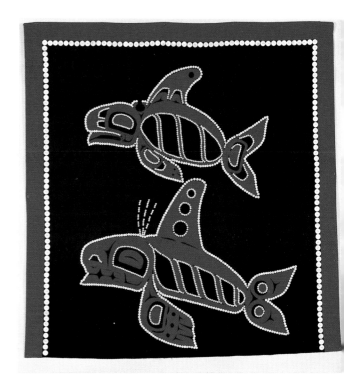

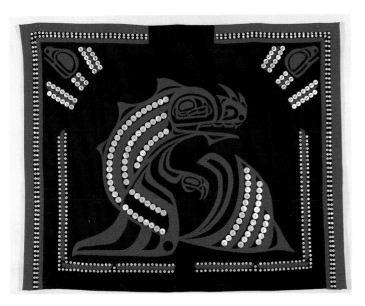

"I like doing what I'm doing because I think it is worth while, and it is the only way that the younger generation will learn. That is the only way they will see it." Fanny Smith, 1985

Plate VI
Designed by Ken Mowatt (Gitksan), 1985
Sewn by Fanny Smith (Gitksan)
Navy cloth, red appliqué, shell buttons
A *Halilaa* design from the Weget legends.

15

Figure 11. Chuck Heit attaching crest appliqué.
Figure 12. Margaret Heit.

Chuck Heit was born in 1957 in Hazelton, B.C. He began carving at age fifteen. Although he has studied at the Kitanmax School of Northwest Coast Indian Art, his greatest influence has been his uncle, master carver Walter Harris. Chuck Heit works primarily in wood, but has also produced a number of highly regarded prints.

Margaret Heit was born in 1929 at Balmoral Cannery, located on the Skeena River. She comes from the House of Geel, of which her brother, Walter Harris, is presently head. In 1979, she made her first button blanket. At that time, her knowledge of the history of button blankets was only that the chiefs wore them. The Two Killerwhale crest was received by her mother's family as a gift from a high-ranking Coast Tsimshian chief.

Margaret Heit *This design for my button blanket was inspired by my mother's reminiscence of olden days. I sketched a picture, and my son Chuck came up with the design. The description from Mother sounded so peaceful and beautiful, and I have enjoyed sewing on the design and the 1,758 buttons. If this blanket were to be worn and owned by Chuck, it should have been sewn by a member of my father's family, the Wolf clan.*

According to Mother, it is our custom to provide the design, material and buttons, or whatever you wish to be sewn on your blanket, to close relatives on the father's side. Payment to those who helped make the blanket would be done at a feast. At this feast, the blanket would be officially placed on the owner. He would call out the names of those who made it and publicly make payment. The owner would give out money and gifts at this time to validate his new button blanket.

This blanket is made of pure wool with pearl buttons. It is also prepared for hanging as well as to be worn. The design represents our family crest, 'Laau-gim-n'eexhl', which means, "Drifting Killerwhales."

Ken Mowatt was born in Hazelton, B.C., in 1944. He is an instructor at the Kitanmax School of Northwest Coast Indian Art. He excels in the craft of screenprinting and is also a superb woodcarver.

Vernon Stephens was born in Hazelton, B.C., in 1949. Vernon is one of the main instructors at the Kitanmax School of Northwest Coast Indian Art at 'Ksan. A master carver, he specializes in two-dimensional design.

Fanny Smith, Gitksan, was born in Hazelton, B.C., in 1924. She was brought up in traditional ways. Fanny is one of the finest of 'Ksan's button-blanket makers, having to her credit the spectacular Sun blanket and many others, including two blankets for **Robes of Power.** Fanny is one of the few people who can write her own language "fluently," and she is a careful researcher for 'Ksan's studies of dance, song, history, and traditional techniques. Fanny is married and has four children and five grandchildren.

Fanny Smith *I was born on a cold January day in my grandmother's house. I was delivered by my grandmother. I spent quite a bit of time with her. She talked about the old ways a lot, but I really didn't pay much attention. That is how it is when you are a child.*

My first memory of button blankets was just before I was ten. My grandfather had his in a bentwood box, and he used to take it out to look at it. My grandparents had two or three of those bentwood boxes and used them to store valuables in. My grandfather did not really say anything. He would just take the blanket out to check and see if it was still okay. The blanket was navy with red trim and buttons. My grandfather called it gwiis-gan-m'ala.

My grandfather never wore his blanket when he went as a guest at a feast. Maybe they wore them more in ancient times, but not in my time. I wouldn't say that they were not proud of them any more. They had served their purpose.

In 1969, I saw button blankets being worn at the official signing ceremony for 'Ksan Village at Totem Park. There were performances celebrating the signing. I was a bit surprised, because I had never seen them being worn like that. I always understood that they were worn only at feasts.

The first button blanket I made was in 1972 when I was with 'Ksan Performing Arts, and they were getting ready to go to Ottawa. Time was running out, and they needed a blanket for the performance. They needed a Sun blanket and someone to sew the buttons on, so they talked me into sewing. Since then, I have made a few blankets for the 'Ksan Performing Arts.

The blanket I wear at 'Ksan Village performances has a Frog design: I am playing a role there. I like wearing the blanket. It feels good. I like doing what I'm doing because I think it is worth while, and it is the only way that the younger generation will learn. That is the only way they will see it. The feasts are not the way they used to be in our great-grandfathers' time. There was a lot of discipline in the old days at the feasts. It was like walking into a revered place. You don't step out of line, and you act properly.

I don't think that I will make a button blanket for myself, because I don't feel I have earned one. We do not get a button blanket just because we want one. We have to put on quite a few feasts before we have the right to own a button blanket with a crest. That is the way we were taught.

I was at a bridal shower some time ago, and one lady was in conversation with another. She was saying that she was going to get herself a vest with her ayuks *[crest] on it. This elderly lady who comes from the same clan told her, "You don't wear a crest, you don't wear your* ayuks *until you have had quite a few feasts and have earned it. Today even little children are wearing crests, they are packing crests on their backs." After that, she cancelled her ideas of having the vest made.*

Vernon's blanket design is a crab design. There is a moon on each upper corner and it is outlined in dentalium shells. There is no appliqué except for the border. Ken Mowatt drew his design on one big blanket-sized cardboard. I used duffle on these blankets, to me they look the nicest, but the dancers do not like to wear them because they are too heavy. To me they are the "real blanket" because the old ones were made out of duffle.

The button blankets are important. When you wear your blanket they immediately know who you are and what House you come from, when they see what you have on your blanket.

Some of the designs you see on the Gitksan blankets, the geometric designs, represent shadows. I heard this from a lady from one of the villages. She called it "shadows."

Our word for the button blanket or robe is gwiis-gan-m'ala, *which means a robe with buttons.* Gwiis *is a robe or something that you cover yourself with. In one of the Weget legends, they call Weget's little tattered robe* Gwiis gak *[literally, "Robe Raven"]. That's an ancient story, so* gwiis *has meant "robe" for a long time.*

Figure 13. Fanny Smith working on button robe.

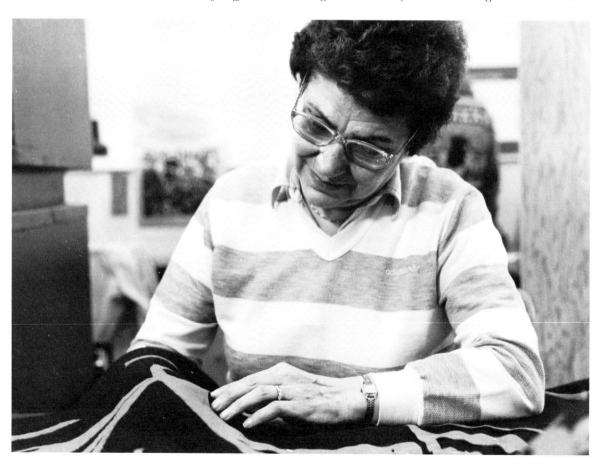

Dorothy Grant, Haida, was born in 1955 at Hydaburg, Alaska. Her cultural awareness stems primarily from her grandmother and, later, her aunt, who had an influence on Dorothy's identity as a native woman. In 1983, she was a guest curator of an exhibition of textile arts of British Columbia coastal native women, called **A Quiet Wealth.** She is a weaver of spruce-root baskets and hats, and works with Robert Davidson in creating ceremonial regalia, primarily blankets, usually with extensive appliqué borders.

Robert Charles Davidson was born in Hydaburg, Alaska in November 1946, second born to Claude and Vivian Davidson. He was named after his grandfather, Robert Davidson, and his great-grandfather, Charles Edenshaw. When he was a child, his family moved to Masset, his father's village.

He began carving when he was a teenager. In 1965, he moved to Vancouver to complete his education. In Vancouver he apprenticed with Bill Reid, the well-known Haida artist: later, he attended the Vancouver School of Art. A thorough understanding of traditional Haida sculpture and design, combined with a high degree of innovation, has made Robert Davidson's work in wood, silver, gold, and graphics greatly sought after by collectors. His work is in museums and private collections all over the world. Robert now makes his home in Surrey, with a studio at Semiahmoo Village.

Robert Davidson *I was born in Hydaburg, Alaska. My mother is from Hydaburg and my dad is from Masset. We moved to Masset when I was a child. My mother was in hospital for a couple of years with T.B., so I spent some time with my grandparents. I don't remember that part of my life at all. I was too young.*

When I was older, I spent more time with my grandparents. It was important to them that I learn certain things: how to live, how to dig for

clams, and how to dry fish. My grandfather and my dad were carving argillite at that time from Marius Barbeau's photographs. It was my dad who strongly influenced me to start carving in argillite. Just being around them carving, I started to become interested. It was the first time I was aware that there was more than what there was in the village, which was nothing in terms of art.

I spent several years (1966-68) in Vancouver, going to high school and apprenticing with Bill Reid, and in Hazelton, teaching carving at Kitanmax School. There were all these questions from the white people about the culture. I didn't know anything about it. I was curious. I started going to museums, where I saw these incredible carvings. It really helped me and influenced my work.

With the experience and knowledge I gained, I went back to my village in 1969 and carved a totem pole. That's when things started to open up and they started making button blankets for the pole raising. I didn't know anything about blanket designs except for what I had seen in museums. One of my frustrations was maintaining the tension of the design while using fabric. I could see the tensions in the fabric. A knowledgeable blanket maker determines which side of the pencil line to cut on. I had to learn to think of the problems for the person who would do the sewing. I put in bridges to hold the design elements in place, the teeth and lower lip together, for instance. It's funny—I guess blanket sewing is like knitting: most have to follow a pattern. My Aunt Aggie, for example, can just draw and cut it out beautifully.

It's like building a house with a foundation plan. All the forms have to be in proportion. It's not only the pattern, but also the colour. You can emphasize some lines with buttons or without buttons. You don't have to make it fully buttoned.

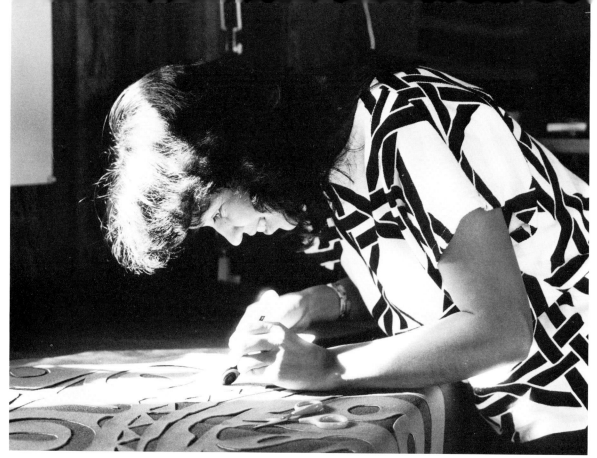

Figure 14. Dorothy Grant working on button robe.

Figure 15. Robert Davidson working on template for button robe.

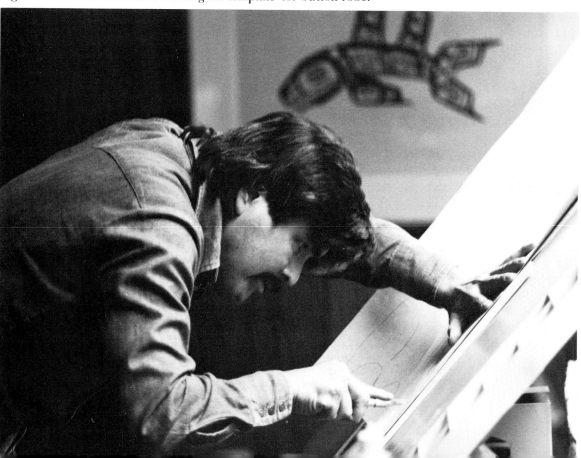

One thing I've never done is explore the materials. I've always made the patterns, and all I see is the colour rather than the limitations of the material. It's the only form of the art I'm not fully involved with. When I do anything other than blankets, I become fully involved. I do blanket designs sporadically. Sometimes I'll do three or four, and then two or three years later I'll do another. There are certain rewards, like the reward for doing the last two designs—two buckets of seaweed! I really appreciated it. I get frustrated sometimes when someone asks me for a pattern for a button blanket. I guess it is because at the time I am not emotionally involved.

I go through a lot of emotional energy to create. People say how easy it is for me to draw a design. It takes a long time to think about the design. It may take two days or it may take longer. Then it just comes. I never know exactly when it will come. Creating is just a continual learning process. I keep forgetting what the exercise teaches us and the patience with the learning that we all have to go through.

People get frustrated because I'm really fussy. The lines cannot waver. They say "wow" when they look at the design. The lines are beautiful because everything works with everything else. It takes time.

When I started designing button blankets in 1969 I had to do it from scratch, really simple ones. They weren't innovations. They were variations of other designs. I saw a blanket in Hazelton that really helped me. [Robert designed two hasty-note cards for 'Ksan, using the Frog crest blanket design and a Sea Bear design from an old Haida blanket.]

My purpose for carving the totem pole in Masset in 1969 was so that people could celebrate one more time before they die, especially the elders. They had several meetings at Nonnie's [Florence Davidson's] for the totem pole raising, and some of the elders asked, "Can you make a blanket design for me?" I don't know how many I designed. I did a four-finned Killerwhale and a Killerwhale with a small fin, probably a Blackfish. These were their favourite personal crests. Besides designing these blankets and getting the totem pole finished and a dance screen to make, there were discussion meetings. Ten years later, I don't know how I did it, but I realized why I did it. It was a celebration for the old people, so they could celebrate one more time before they die. We're still celebrating. It was a learning experience where knowledge couldn't have been transferred any other way. All the potlatches are the same: it is knowledge that is not written down. It is sacred and private. It's a personal experience.

I did my homework for the 1983 potlatch. When I adopted Joe David and gave him a name, it was because I saw too many names being given away outside the village. I was demonstrating what I was taught. When you give a name, you have this public doing where you make a statement with confidence which holds true with all the people who are there. The name is very important. It is more important than a five-inch gold bracelet! What I was doing was giving Joe a name from my tribe, Tsaahllanas. Besides giving him a name, I gave him a button blanket. He received my crest, and he's entitled to our songs and all the things that I'm entitled to through that name. You have to validate the name and the blanket. The crest on the blanket is a two-headed Eagle. It's an important crest to our tribe and was given to Joe David. It's a crest that is not used often. The border has a spiritual significance. The name the elders chose to give Joe was Skilk'aahluus, which means, "Wealth spirit rising." The name belonged and is still used by the elder who gave Joe the name. In Masset, there are very few names, because only a few people remember the old names. I first started planning the potlatch for Joe, and then I started thinking in other directions. It was time for everybody to do what they were always talking about—giving names to their grandchildren.

Before the potlatch, I went through the whole village, knocking on doors, inviting people. The first day of the potlatch was for Ravens, and the second day was for Eagles. It was so controversial. Some people were all for it and others were against it...

On the day of the naming, people who were negative towards it changed. They never had a name before. I don't know what it was, but those names became very important.

It is the same with button blankets. Sometimes we don't realize how important these blankets are. They are powerful symbols. When people are at a dance without a blanket, they don't dance. They say, "I don't have a blanket." It's a first reaction.

Joe David gave me a button blanket at the same potlatch. The design on it is a Wolf transforming into a Whale. It's a beautiful design. But in the old way, he has to validate it in his own village, the fact that he gave me a blanket. I don't feel right about using it until it's validated.

I was introduced to the button blanket midway through my life. When I first put the button blanket on, I feel shy. Even when I sing, I feel shy. When I do a painting, it takes me a while to show it to anyone. One mask I hid away for a year before I showed anyone. I'm working on breaking away from that fear. I'm practising my singing more. I think it has a lot to do with movies and stories about Indians. The Indians were always the bad guys. They were always losing, and it had a strong effect on me. It's taken me a long time to get rid of that feeling. Now I'm all excited about being Indian. I'm doing things to improve my dancing.

Dorothy and I have started designing the borders with appliqué. I started thinking more about the shape of the blanket and how it worked for dancing. We were pinning up the corners. It made them look like Chilkat blankets.

I got the idea of designing a blanket with fringes from a photograph of a dancer who had really long fringes on her dress. I thought, what a good idea: so I thought of designing blankets with white fringes. I'm starting to design blankets with a lot more confidence. I'd like to design a really nice one for myself now. What I want to do is adopt a crest, and that would mean another potlatch. The crest I was thinking of, and presently using as my logo, is the crescent moon with a human face inside of it. To me it symbolizes a self-portrait, a communication with my hands. The hands become the mouth. I thought it would be neat to start introducing new crests. When the white man first came, they [the Haida] were still adopting crests. For example, there is a family from Yan that adopted the dogwood for a crest.

That reminds me of a story about my grandmother. I've always thought of Sara [Robert's daughter] as a butterfly. So I did butterflies for her on one blanket. I asked my grandmother, "Isn't the butterfly part of the Raven clan?" She said, "I don't know, but we'll claim it!"

The whole idea of the button blanket is to show your crest. The design on the back shows what tribe or clan you came from. I've never really thought about the border. On the bottom it doesn't need a border, because you need it that way for dancing. If you close off the bottom, it doesn't feel right: I've never ever thought of doing a border on the bottom. The first button blankets I designed, I didn't insert material in the neck area. The top border went straight through. Then I saw a photograph of someone wearing a fitted blanket. It looked neater than the ones I designed, so I started designing them like that. I know there are reasons for the omission, but I don't know them. The material inserted in the neck area could be to keep the grease off. When I am designing the borders, I plan it so that, as the borders come together, the design works. The border frames you: it puts an emphasis on you. When they're looking at you, you're framed beautifully.

Figure 16. Freda Diesing.

Freda Diesing lives in Terrace, B.C., although she is a Haida. She completed grade school and then attended the Vancouver School of Art. She began her serious study of Northwest Coast art when she chose to make a model of a complete Haida village to celebrate a local centennial. She continued her studies at Kitanmax School of Northwest Coast Indian Art in Hazelton. She contributed much while she was at 'Ksan, the site of this school, and extended her visit to study and participate further. Freda teaches in Terrace and Alaska, carves, sews, and produces silkscreen prints.

Freda Diesing *My first button blanket was made for the official opening of 'Ksan in 1970. Florence Davidson helped me sew the buttons on it. It wasn't finished, and the celebration was coming up, and so a whole lot of people helped me sew. It was made with plastic buttons, but they really looked nice.*

I just made blankets for dolls before. Actually, my first project was in 1967, centennial year. It was a scene of dolls dressed in blankets, a canoe, and an Indian house. It was displayed at the first Indian Days in Prince Rupert. After that, I was working at 'Ksan, and I was designing button blankets and cutting the designs out. Other people were sewing them, so I never sewed until I made this one for Robes of Power.

I had this Hudson's Bay blanket for ten years or more and had been buying buttons over that time, and I'm really happy that I did, because now there aren't any to be found in the stores. I've decided to do my crest that I'm allowed to wear, the Eagle crest. The main story of our family is the one that goes with my name. It's a little woman carrying a baby and it's called a Skil. I was given the name Skil-que-wat, which means, "On the fairy's trail; going to the woods to find the fairy." It was Uncle Daniel Stanley's name. It was the anthropologists that gave it the name, "fairy." It was really a small supernatural woman.

Usually, the animal crest of the chief or woman of rank was depicted on the blanket or dress. Crests are inherited from the mother. My crest is the Eagle. My blanket shows my family's crest, and is made in honour of my grandmother and her brothers and uncles who, by reason of the times in which they lived, did not have a totem raised in their honour.

Figure 17. Freda Diesing (far right) with her mother Flossie Lambly and Doreen Jensen (centre).

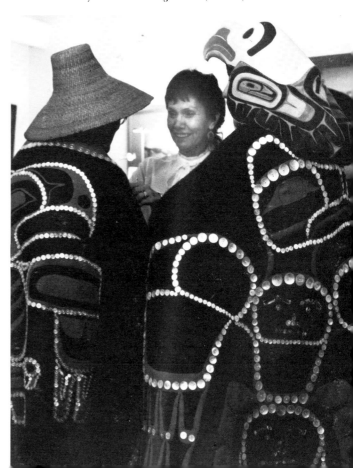

Figure 18. Hazel Simeon and her grandson Jacob.

Hazel Simeon is a remarkable lady. She was born in 1941 at Masset, B.C. Her grandmother, Mary Bell, and her mother, Grace Wilson Dewitt, have strongly influenced her life and work. She knows the exacting details of her family line, traced through the women to an uncle long ago. She holds both Haida and Tlingit titles and is included when feasts are planned. Hazel shares her knowledge by teaching her own children and grandchildren Haida songs, dances, and button-blanket making. She travels to the Canadian prairies and the American southwest to visit Indian people and exchange cultural information. These trips are financed with her own earnings. Hazel makes both button- and Chilkat-style ceremonial robes for many chiefs in British Columbia. She lives in Vancouver.

Hazel Simeon *When I was twelve years old, my grandmother, Mary Bell, gave me an Indian name,* Jut-ke-nay. *It means, "The one people speak of." They weren't allowed to potlatch, so all she did was she got her drum out, started to sing, and said she was handing down her Indian name to me. Then we had a little supper and I had a new name.*

I have another Indian name, Ka-soo-di-nay. *It means, "Leader of Killerwhales." It is Tlingit. I use that name when I am in Alaska. My stepfather,*

Forest Dewitt, gave me that name. He adopted my mom's family, and I am considered one of the family when I go to Alaska. I am included in all the planning and everything that goes on within the family. The crest on my button blanket is the Killerwhale with an extra-high dorsal fin. This is my grandmother Mary Bell's crest, and this is the way it was presented to us. The circle and the dot on the dorsal fin is Mary Bell's signature. There are slight variations to the original design. My mother and I have the same pattern, and the only difference is on the tail, and mine has a little mouth on it with teeth. That is my signature. My niece has buttons across the fin on hers, and it's her signature.

The Killerwhale with an extra-high fin is our Haida crest, which comes from our Alaskan side. It is supposed to have come from my uncle who was saved by the Killerwhale. After all the help they gave him, he adopted the Killerwhale with the high fin. The design was given to Mary Bell by the uncle. The fin is long and split in the middle, and the tail must always have the cat design. It's only been passed down in oral tradition. My children know about it, and whenever we see my mother she reminds us of who we are, where we come from, and what it stands for. It's like our name. It identifies us wherever we go. So people know I am Mary Bell's descendant.

My mother was going to wear her button blanket at a potlatch, but it was too heavy, so she gave it to me to wear. The design will have to be removed because it belongs specifically to her. I'm going to Masset, and I will put on a Haida design, the Raven and the Eagle. I'll be wearing it at the opening ceremony up there. I've been away from my village for thirteen years, yet I have never lost my place. Everybody knows who I am. When they see the design, they know immediately.

We started travelling because we were interested in native culture, and curious about Prairie Indians and the way they were. We brought our stuff to wear, showed them what we had, and we were accepted as their people. It was just like home. They are like our people. And yet, their culture and their ways are so different.

I met a seventy-two-year-old man who said when he was sixteen he saw some Haidas. He hadn't seen another Haida for almost sixty years and he thought we had lost our culture. He thought we all died. He was happy to see us!

One of our tents is painted in Northwest Coast designs, and this identifies us as who we are. I make aprons, vests, dresses, leggings, and head-bands to trade with. I sew blankets and costumes. Everywhere we go now, everybody knows us. They always give us cans of old buttons. By the time we get home we have quite a bit in the car, and then I just separate them.

My stepfather has given me some designs that I use. I never use anything that doesn't belong to me. I even use something that was popular a few years ago, which was the Phoenix, from Arizona. The people looked at it and said, "That is a Thunderbird." I told them it was the Phoenix, and everybody wanted one.

We just came back from Alaska, where I gave away eight blankets. I was able to sell some other items too. It provided us with money for our trip, plus money for our next trip to Masset. My mother and I made blankets for the family, and only the family. We never sold any until I moved to Vancouver thirteen years ago. I haven't the slightest idea how many blankets and costumes I have made, but everywhere we go I see my work. When we were in Alaska, seventy-five per cent of the people had my work. The blanket sales provide us with our van, food, and gas. I have ten children, only four left at home. I travel with my three daughters. My son is still living at home, but he never travels with us because he is always in school. One grandson lives with me: he travels with us. We call it travelling on "blanket power."

Figure 19. Carrie Weir with her daughter, Millie Yeomans.

Carrie Weir is an eighty-two-year-old jet-setter. The blanket designs she uses are provided by her son, Alec. Her niece in Vancouver has two beautiful robes crafted by Mrs. Weir. She has a serious concern that her family and others know the truth about Haida traditions. Like her cousin, Florence Davidson, Mrs. Weir lives in Masset. She uses red and yellow cedar bark and spruce root to weave items long used by her people, and teaches basket weaving as well. Mrs. Weir is active in her church. She is very talented, has many friends, and keeps very busy.

Carrie Weir *I was born in Howkan, Alaska. I am past eighty. My father was from Alaska, and he used to carve. He owned a store in Hydaburg. My mother was from this side. We moved to Masset in 1918.*

I started making button blankets in 1965. My cousin, Esther, phoned me and invited my husband and me to the National Brotherhood Convention in Hydaburg, Alaska. I made a button blanket with the Bear design before we went. My husband just had a drum, so he took my blanket. My husband was a good singer, and because they liked him so much they made him song leader. He never bothered to use the button blanket, just went on beating his drum. On the second night of the convention, we started dancing with the button blankets.

I made a mistake on the border. Elsie Douglas (she is older than me) told me about it. I had a red border on the bottom, and it is not supposed to be there. So I took it off right away after the dance. Ever since then, I make it like the way it is now. I don't know why it is supposed to be like that. There is a meaning for it. Some people use light green and light blue, but it looks funny to me: it's supposed to be Indian colours—red, navy blue, white or black. When we came home, I made a button blanket for my husband. I haven't stopped yet. I make them for my family all the time. The last one I made was for my son, Pat. I asked him, "How many blankets did I make for you?" and he said, "Five with this one." I make some to sell, and most people like them for wall decorations. I saw a photo of a blanket that is like my white blanket. I'm going to make one with red buttons. I have some real old ones. Every year since 1965, we have been invited to Alaska. My cousin, Esther, loves me so much. She invites me to everything.

We try to make button blankets for everyone in the family, because we need them. You are supposed to use your own crests, nobody else's.

When I was a young girl, I was given an Indian name, It-ca-sak-ki-nas. My mother forgot what my name means. It-ca-sak means, "Rich lady." I wish I was rich!

Francis Williams is a goldsmith in Vancouver. He was born in 1936 at Masset, B.C. By 1960, he was exploring the art of the Haida. He began by studying the ancient works in the B.C. Provincial Museum in Victoria, and learned the complexity of Northwest Coast designs. In the mid-1960s, he learned to carve, and is now ready to instruct apprentices. His piece for the **Robes of Power** exhibit was his first button-blanket commission.

Francis Williams *When I was a child, there was no Indian art as we know Indian art today. When I was fifteen years old, I picked up a Barbeau book and started to look through it. I asked myself, "What is this? How come this stuff is not around any more?" Everybody said that it was old stuff and that we did not need it any more.*

During my childhood, we denied being native. It wasn't cool to be native. When I was about thirty-two, I went to art school in Victoria and discovered the Provincial Museum. I began to really understand the sophistication of the old stuff. When I looked at the artifacts, I thought, "This is what I'm about!" It was a slow process of learning how important this was in my life. As I grow older, this becomes more fascinating, because I think about how I could have missed the

opportunity of discovering it. It has given me an identity. It puts more value into my life, being a vision maker, as one person said; being that part of a people that creates visions and pictures in the same way dancers do. They bring to life what I create on button blankets.

I first saw Chilkat blankets as works of art. I knew they were used in ceremonies, but I had no idea how. I was told at the museum that they were worn by the chiefs in special ceremonies. In later years, I became aware of what the dance robes were. Today, I realize the importance of the dance robe. I remember an exhibition I saw. When I walked in, I was overwhelmed by the power of the robes, and I couldn't find the words to express myself. There was something about this that was so important. There was so much power in them, an important message that was trying to come through. Not everybody picked it up. I guess for me, it was overwhelming to see the robes all in one room. Wow! It was just too much! These ceremonial robes (I don't like to call them blankets, because they are dance robes) are used to display your lineage and display it proudly. They are worn like a king wears his robe.

The design I'm using on my button blanket is the Killerwhale. I sat and looked at the whale design for three days and I kept saying, "To me, it's

Figure 20. Francis Williams with whale designs for button robe.

beautiful." I am from the Raven clan and the Killerwhale is one of our many crests. I hung it on the wall and positioned it in different ways to see where it was not beautiful. But it was still beautiful, so I knew I had done a good job. Actually, I'm very pleased with it. I guess this exhibition has awakened me to the importance of what a dance robe is.

Now that I am producing button blankets, I am really excited about it. It is an offshoot of the work I do. I am a metalsmith and I make silver and gold jewellery. It is a precision art, because no matter how large or small a Northwest Coast design is, it has to be perfect. There is no room for, "Okay, that's good enough."

I do not have an official Indian name. I was called Yelth-cwa-was: *in Haida, it means, "Raven sitting" or, to put it comically, "Lazy Raven." An old aunt of mine gave me that name. Strange, but when I was young, mom would let me play on the beach and every day she would ask, "Who did you see on the beach today?" I would say that I was playing with this old man who was sitting on a log. One day, I told her his name was* Yelth-cwa-was. *She looked at me with surprise and said, "Who told you that?" I said, "The old man told me." The strange thing is, he had been dead for twelve or thirteen years. I had never heard her say that name. I actually saw this old man. He would sit and watch me play. I never touched him, just looked at him: it was a vision. The Haida believe very strongly in reincarnation. So that is why they started calling me* Yelth-cwa-was. *It is an experience that I often tell people when they ask about my name.*

If I wanted to make my name official, I would have to speak to my last surviving auntie, Aunt Effie in Prince Rupert. I would have to find out exactly who the old man was. Getting a new name would be like a new stage in my life. Maybe the turning-point in my life is this button blanket.

Dora Cook and Louisa Assu, Kwagiutl, were both born in Alert Bay, B.C. Dora was born in 1929, and Louisa in 1933. They grew up at Village Island. In their teens, their family moved to Alert Bay. They were brought up with strong traditional customs taught them by parents and grandparents.

For a short time, Dora managed a native arts and crafts shop in Vancouver, promoting native artists. Dora is an excellent carver. She was one of the carvers of the tallest totem pole in the world, located at Alert Bay. She also carved the large doors at the Vancouver Indian Centre and the welcoming poles located on the grounds of the Kwagiutl Nu'yum'ba'lees Museum at Cape Mudge village. She has been requested by many of her own people to design ceremonial screens for their potlatches.

Louisa has made many button blankets for her own family. The crests on these blankets were designed by Dora, and the sewing was done by Louisa.

In 1982, they were approached by the Kwagiutl Nu'yum'ba'lees Museum to teach their skill of blanket making to several ladies. They taught many women to design and make button blankets during the winter months of 1982-83 and 1983-84. Classes were held twice a week, with twenty-four students in each class. The students were taught the traditions of the Northwest Coast pertaining to the button blanket.

Two weeks after the completion of the blankets, some of the students were taught the traditional ladies' dances by Lucy Olney. Lucy is Dora's and Louisa's sister. During their dance lessons, they wore the blankets they made.

(By Daisy Sewid Smith)

Figure 21. Dora Sewid Cook.

Figure 22. Louisa Sewid Assu.

Dora Cook *This blanket is a replica of the button blanket my grandmother gave me 25 to 30 years ago. She had it stored away for many years, until we started our traditional performances again. She just called me in one day and said, "I want you to take this blanket and keep it, it's yours. Pass it on to your young." During that time, the people would pass things on to other people. They didn't necessarily have to have a ceremony when this was done. It could be validated at a later date, during the next family potlatch. I also remember my grandmother laughing at me because I could not dance. I got mad and stood in front of a mirror and practised dancing until I knew how.*

The name of the design on this blanket is Gwa'ka'lee'ka'la, which means, "Tree of Life." Our *use of the cedar tree is symbolized here. We made our big houses from the cedar. As well, we made our cooking utensils, woven cedar bark mats for the houses, canoes, and it was also used as fuel for our fires. We even made racks from the cedar for drying fish. We called this gah'hah'dum. Our clothing was made out of cedar bark too. Everything we used was connected to the cedar tree.*

The red border on the button blankets goes back to the days when robes were made from yellow and red cedar. Noble people would use sea-otter fur for the borders. When the white people came, we started to use the red cloth border. We did everything in fours. That is the meaning of the four circles that are so often mistaken for a dogwood flower.

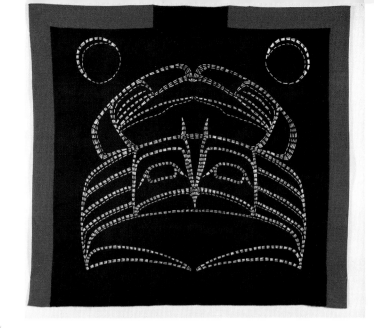

"When you wear your [button] blanket they immediately know who you are and what House you come from." Fanny Smith, 1985

Plate VII

Designed by Vernon Stephens (Gitksan), 1985
Sewn by Fanny Smith (Gitksan)
Navy cloth, red borders, dentalium-shell decoration
Crab and Moon design.

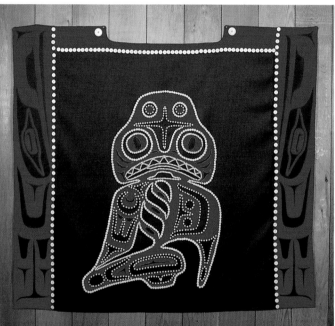

"People are starting to get curious about crests and interested in button blankets. It's a vehicle to learn more about our heritage."
Robert Davidson, 1985

Plate VIII

Designed by Robert Davidson (Haida), 1985
Sewn by Dorothy Grant (Haida)
Royal blue with red border and appliqué, mother-of-pearl buttons, blue glass beads
The design is Dogfish (shark) on the main part of robe, Raven on the border.

"The family would work for several years to make the finest regalia to be worn or to be given away at a potlatch."
Freda Diesing, 1985

Plate IX

Designed and sewn by Freda Diesing (Haida), 1985
Navy duffle cloth, red melton cloth border and appliqué, abalone and mother-of-pearl buttons
Eagle design—Freda's clan crest.
Made in honour of her grandmother and her grandmother's brothers and uncles.

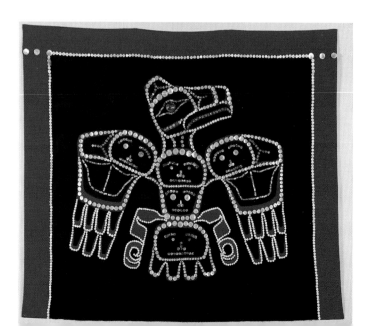

"The blanket sales provide us with our van, food, and gas. I travel with my three daughters. We call it travelling on 'blanket power.'"

Hazel Simeon, 1985

Plate X

Designed and sewn by Hazel Simeon (Haida), 1985

Old red three-point Hudson's Bay blanket, new black appliqué, old mother-of-pearl buttons (1,552 buttons used)

The design is "Great Killerwhale," her family crest. The design on the whale's tail is Hazel Simeon's signature.

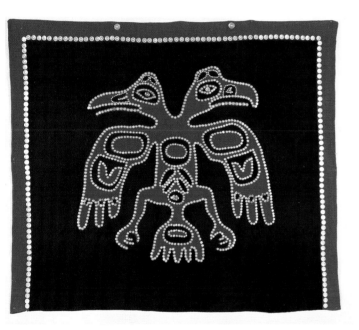

"We try to make button blankets for everyone in the family, because we need them. You are supposed to use your own crests, nobody else's." Carrie Weir, 1985

Plate XI

Designed and sewn by Carrie Weir (Haida), 1985

Navy cloth, red appliqué, plastic buttons

The design is a double-headed bird, Raven and Eagle, two clans of the Haida.

"There was so much power in them, an important message that was trying to come through These ceremonial robes are used to display your lineage and display it proudly ... like a king wears his robe." Francis Williams, 1985

Plate XII

Designed by Francis Williams (Haida), 1985

Sewn by Hazel Simeon (Haida)

Navy and red wool, old pearl buttons

The design is a Killerwhale, one of Francis's crests.

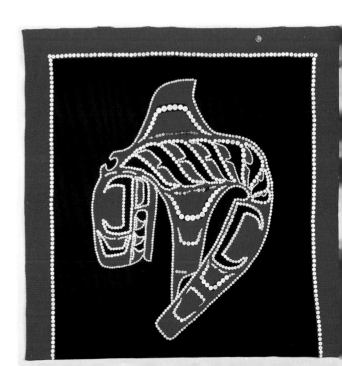

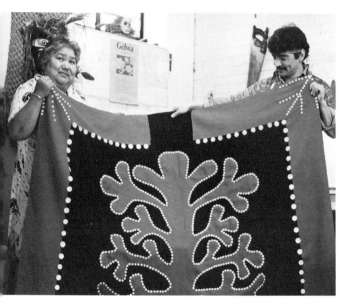

Figure 23. Simon Dick with his mother, Gertrude.

Simon Dick was born a Kwagiutl in 1951 at Alert Bay, B.C. In ancient times, he might have grown up to be a medicine man. He was raised in the village of Kingcome, where the traditional lifestyle is still present. His knowledge of his culture stems from the teachings of the elders of the Kwak'wala dialect, in which he is fluent. He is the grandson of hereditary chiefs on both sides of his family. An excellent carver, he has produced bowls, masks, poles, and assisted with a canoe for Expo 86. A traditional dancer, he has not only potlatched but also performed internationally. He now makes his home in Vancouver, where he has a studio.

Gertrude Dick was born at Knight Inlet in 1930. She has two sons, one daughter, and seven grandchildren.

Gertrude has been making button blankets for twenty years, but this is the first button blanket she and her son Simon have worked on together. They chose the "Tree of Life" design and used the black and red material Simon had given her one Christmas.

Gertrude frequents second-hand stores, looking for old buttons. She acquired four old square abalone buttons at a potlatch. She is saving them for another button blanket. According to Gertrude, "Someone said that some old people went to Japan and got blue abalone shells. This was in the 1800s."

Simon Dick *While I was studying my art and culture, I never really asked questions about button blankets. It is just that I have always felt it was your mother's duty or your grandmother's duty to make blankets. My mother has been making button blankets for twenty years. I felt that that part of the arts was going to be forever protected.*

I didn't really focus on them until now. Let's go back a few years and ask when we should have. Actually, we have lost quite a bit of information on the origins of them. Button blankets definitely play a role in identification and rank, but if we are just going to talk about button blankets, there could be hundreds of questions that remain unanswered.

I have one blanket stored away that I have never worn, because of the reason it was given to me. An elderly lady, Elizabeth Quocksister from Knight Inlet, said one day that she was making me a medicine-man's robe. She did not tell me the reason. It was not until she gave a potlatch for her late father that I learned why. There, she called me up to the head of the house to receive this medicine-man's robe. She placed it on my back. She said it was for all the good things I had done for her father, like asking him questions about certain dances, paying attention to him, and having so much respect for him. The robe was made of rough burlap and dyed bright red. It is fringed, with no buttons. Tiny seashells, abalone

shells, and duck feathers are tied to it. A double-headed sea serpent has been painted on with gold acrylic. I didn't know at the time that she was dying of cancer. When I finally asked her why she felt that I was so deserving of such a blanket, she said, "You are a medicine man! All the medication that I have been going through hasn't helped, but when I see your smile, that's the medicine I treasure the most." I put the robe away. I will only use it for something very special.

The early blankets had mirrors. They had just one or two mirrors. Like looking into the water for the first time and seeing a reflection of yourself, seeing an image that you have never seen. Hundreds of other people see it constantly, so if you look at yourself, you are actually getting a more psychological image of who that human being is, so that the longer you look, the deeper you might see. That's why I feel mirrors were placed on a blanket: when someone looks into a mirror, they see themselves also in you.

Imagine seeing the first abalone shell, the colour and shine. You would instantly recognize it as jewellery, coming as a gift from the sea. So it is a gift from nature, and highly treasured.

The "Tree of Life" design has always been one of the predominant crests of the Kwagiutl. I have seen a lot of different families use it, so it is shared quite openly among us. No particular village has tried to take responsibility for the origin of the crest. Personally, I have always liked the design. I discussed it with my mom, and we agreed that this would be the design we would do for the exhibition. This is the first time my mother and I have worked together. It was exciting that we were going to do something together.

When I go to a potlatch and see others dancing with blankets, I see two things happening: I see the Thunderbird or Raven or Salmon on the robe, and I see Thunderbird or Raven or Salmon in motion around the fire. That is how I appreciate the blankets.

Marion Hunt Doig's strength is adaptability. Though she lives in Prince George, outside the geographical area of the Northwest Coast, she was born to a Nootka (Nuu-Chah-Nulth) mother and Kwagiutl father at Alert Bay in 1933. She grew up in Fort Rupert, a village on northern Vancouver Island. She moved to Prince George in 1966 and, since 1975, has been promoting the cultural traditions of her people. This began as a show-and-tell session with her children at school. Today, her program consists of workshops and presentations which include an authentic artifact collection, legends, dance, food, and artwork. Marion creates exquisite Chilkat-style blankets and meaningful button blankets.

Marion Hunt Doig *It took me years to get up enough courage to wear my button blanket in public. It wasn't until we had our potlatch. We wore our blankets, and when you were through dancing you went behind a screen to remove and fold the blanket, to be put away in a special chest. I had to break down that wall when I began conducting workshops on Northwest Coast Indian culture at schools. Dad would sing short songs for me on tapes so I could teach children. He said, "It's all right, Marion, for you to educate people about our things, because they're just going to disappear if you don't. It's very important for children to know about our past, the way the old people did things in the old days." So, for two years, I listened to the tapes. Finally, I put my blanket on. That was the first time I ever wore it in public and, even then, I had a few qualms about it. But now it doesn't bother me, because I got the okay from Aunt Maggie and the old people. They said, "It's good what you are doing, teaching children."*

My dad said, "Make a blanket, Marion, you have practised enough. It's time for you to make something that tells a story." I told Dad, "I will make the blanket the way you described it, and then I will come and check it with you before I fill it in, to make sure that I did it right." Then he

had a stroke. I finished the blanket and took it to him in the hospital. I said, "The blanket is finished, Dad. Do you hear me?" He nodded his head. I thought, "The blanket keeps him alive: it keeps them all alive!"

Later the nurses would ask him, "Which daughter is this one?" He would say, "It's Marion, the blanket maker." There was no stopping me after that: it was full speed ahead! I was finally comfortable and sure of my work.

After my father's death, I wanted to design a button blanket in memory of him. He got along well with all people, all tribes. So I chose to use the Thunderbird, who gets along with all tribes. I have seen the Thunderbird on pendants and jewellery. If you travel south to Arizona, you see the Thunderbird. Even in Germany, they have Thunderbird crests. In all the Kwagiutl legends that date back, the Thunderbird has always been the helper of man. He is a friendly bird, not mischievous. I wanted the Thunderbird to dominate the blanket, and it took me a long time to get it just the way I wanted it. I wanted it to be a strong blanket, because my father was a strong man. When I see the blanket now, I think, "There's Dad, with his hand out in friendship!"

The mountain lying on its side on the top border represents the ocean. It says we are from the west coast. The copper symbolizes wealth and power to our Northwest Coast Indians. The top figure on the side border is a whale for our Westcoast (Nuu-Chah-Nulth) Indians, because they are whalers. This is Mom's and Granny's people. The sun design is one of the Hunt crests. I looked up at the sun, and it looked like a diamond. That's why I put the sun like that. Besides being one of the Hunt's crests, it is the giver of life. We all have to have the sun. The salmon sustains life for our Westcoast and Interior people. I used to go fishing with Dad, or even today, when we see whales at the coast, they are free. That is how I remember the fish—free. That is why I have them swimming out of the blanket and not in.

The three lines on the top corners of the blanket signify the different routes our people took to attend potlatches outside their own area. The three directions also represent where my family and I lived. My mother is Westcoast, traditionally. My father is Kwagiutl, and I moved to Prince George. The little line is for me: I came inland. Prince George is home now, yet I love the coast. I love the memories of the coast, especially the elders. Fort Rupert is where I was raised, and it has happy memories for me. That is what I try to put into my blankets.

The red border on the button blanket represents the great winter ceremonies. When the Indian princess came out to open the Red Cedar bark Ceremonies, she wore red cedar bark rings, one on her head and one around her shoulders. The rings were very important, and the hamatsa wears them, which is the highest honour.

Some of the button blankets are so different because our people come from different tribes. Some have more cutouts [appliqué]. I try to go in between and do just a little bit of cutouts. The blankets that I saw when I was a little girl were bold, with hardly any cutouts, yet they played with the buttons. The buttons just covered the blankets! The buttons capture the artist's eye, and with the designs I have to be careful not to wander. In my other blanket, the buttons were touching, and someone said, "You shouldn't let it touch, dear. Space it so your buttons are not rubbing together and not wearing down, and it doesn't weigh a lot. When you are finished, look at it." I had to learn from my first blanket. Then I took it to the old people and I would ask, "Is this all right?"

The cloth that the first traders brought was of different colours, but mostly of the same texture and weight. The navy blue came to us in Fort Rupert, and that is why most of our blankets are navy. I have seen some black blankets, and some wine with green trim. It was very important to use this weight in a blanket, not any lighter or

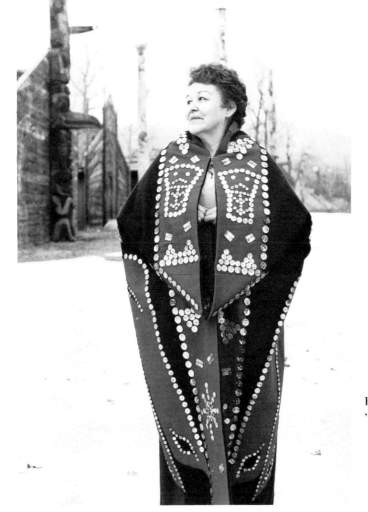

Figure 24. Marion Hunt Doig at 'Ksan Village.

heavier. If you go into a lighter cloth, your blanket won't hang properly. We made a special blanket for my father, who was a big man. We used two and a quarter yards and it didn't look right on him, so we went back to using exactly two yards across. No matter what size you are, it hangs just right. It is the right size.

My mother told me how they used to pick dentalium shells from the bottom of the ocean. A lone man would venture out from the village in his small canoe. He would have a broom-like apparatus, held snug by a ring of coarse bark rope, and besides this he would have additional poles of various lengths. He would have home-made rope to lash the poles as needed. As the broom went down, the pressure of the water forced the ring up off the whisks. It would open wide, picking up the shells, and as soon as he pulled the broom up, the pressure would hold the

shells tight. The broom would close on its upward trip. The shells would be steamed to clean out the animal, polished with sand, and used for trade according to size. We're reminded that the rush-rush of today didn't exist during our ancestors' time, and they truly had time to touch the earth.

If we did not have the old people's knowledge to follow, we would make mistakes. They give us confidence in what we do. I took this blanket to Aunt Maggie, who is eighty-seven. She shook her head and said, "You know, it's a gift." I really believe that, because twenty years ago I couldn't do anything. Now I can look at a button or Chilkat blanket and read the design. I can do many crafts. When someone asks me, "How did you do it?" I say, "I can't explain it." It is coming from somewhere. I have to look over my shoulder to make sure my grandmother is not there, because my hands know what to do.

Richard Hunt was born in Alert Bay, but he has spent most of his life in Victoria, where his father, Henry Hunt, was the chief carver at the Provincial Museum. When his father retired, Richard became the museum's chief carver. He creates traditional ceremonial items for use in potlatches and is renowned for his mask making. He gave the Sisiutl design to his sister for her blanket.

Shirley Hunt Ford was born in 1946 at Alert Bay. Her family lived in Fort Rupert and later moved to Victoria, where she completed her formal education and learned more about the Kwagiutl culture. Her father, Henry Hunt, her brothers, Tony and Richard, and her cousin, Calvin, have all prepared designs for Shirley's blankets. In 1979, she was commissioned by the B.C. Provincial Museum to create a button blanket for the **Legacy** exhibit. The Museum of Anthropology in Hamburg, West Germany, and the National Museum of Man in Ottawa house other of her works. At the 1981 Indian Arts and Crafts Annual Trade Show, she won first prize. She is frequently asked to make ceremonial blankets for relatives.

Shirley Hunt Ford *The first time I made a button blanket was for a memorial potlatch for my mother. She passed away in 1972, and we had*

a potlatch for her in 1974 at the longhouse in Comox.

First, we had to get our designs, and then my sister Noreen ordered all the material needed for the blankets. We found that wool melton material was a nice weight for the main blanket, with felt material for the design and border. The buttons were ordered from Vancouver.

The designs I have are two Sisiutls, one Raven, and one Sun, which my brothers, Tony and Richard, and my cousin Calvin gave me to use for my button blankets.

My oldest daughter married this year, and I presented her with a button blanket at the reception. I used my oldest brother Tony's Raven design. My daughter was very surprised with the presentation, but pleased.

My next project is a blanket for my brother Richard's wife. He has supplied all the materials and is working on the design at the present time. Because I work on a blanket at irregular hours, it may take up to two months to complete one.

At our potlatch ceremonies, I wear a button blanket for the "Woman's Dance." I dance the "taming of the hamatsa" *for my brother Richard, who is a* hamatsa.

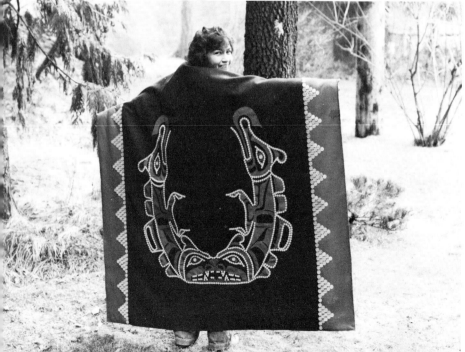

Figure 25. Shirley Hunt Ford wearing a button robe.

Tony Hunt, Kwagiutl, was born in 1942 at Alert Bay. He spent his early childhood at Fort Rupert and, at age ten, moved to Victoria. He began his apprenticeship in traditional Northwest Coast Indian art in 1952 under his maternal uncle, Mungo Martin, whom he called "grandfather," and his father, Henry Hunt. From 1962 to 1972, he was a carver for the B.C. Provincial Museum. In 1970, he opened the Arts of the Raven Gallery in Victoria. The gallery displays the works of Indian artists, and includes a successful training program for young carvers. Tony works with wood, copper, silver, gold, ivory, stone, and silkscreen graphics. His work is represented in major galleries and museums across Canada, the United States, Japan, and Europe.

Tony is a high chief who has received important titles through his mother and father in potlatches. He takes his role as a leader seriously.

Tony Hunt *My very first impression of button blankets is from Mungo Martin, who designed blankets for his wife, Abaya, to sew. All her life, she was working on things like that. Until I started getting ready for my mother's memorial potlatch, I had never designed a button blanket. All of a sudden, I was designing something like fifteen blankets for my sisters and the immediate family. I asked the elders what should go on what. They all had little hints on what is traditional and what belongs to the family, the style, and the shape. Once I had that information, I put the family crests on the blankets. My brother Richard and my father, Henry Hunt, designed other blankets for the family.*

Abaya was always talking about the old things. She and Mungo were always singing. Mungo would be doing something in the kitchen, and all of a sudden he would remember a verse. He'd quickly stop everything, sit down, and pound the kitchen table. He would sing the one verse that he remembered. Abaya, who would be in another room, would hear him and join in the song.

Then, once they got it together, they would sit close together and sing the song until they knew it. They hadn't heard it for forty or fifty years. That's the kind of memory Mungo had, so, even though Abaya was working on something all the time— whether it was knitting, weaving, or making button blankets—that's the way they worked.

I was trained by Mungo Martin. He used to take me out of school to attend potlatches. He would say, "I will take you out of school to go and do more important things." We would go to the villages for two or three weeks for the potlatches. It was there that I would listen to all the meetings and songs. Abaya played a very important role in the potlatch, and nothing much happened until they had her approval. I was too involved with being taught by Mungo, so I never questioned Abaya about what she was doing.

In the late 1940s and early 1950s, the old women liked sequins on their button blankets. They acquired beads and sequins and got carried away with the colours. It looked flashy, and they used them. I remember Mungo saying he didn't like the sequins: he wanted buttons. Today, they have come back to using buttons.

In the early 1960s, I was asked to design blankets for my grandmothers, Grace Nelson and Alice Hunt. I remember Grace's because I designed it quickly, in about five minutes, using a news- paper and drawing it on one side and cutting it. I did it so fast that she couldn't believe it. It was a double-headed serpent, the Sisiutl. *Grace made the design out of sequins. The Sisiutl is very strongly Kingcome Inlet, and it's their crest. My grandmother Grace was from there. She married Alex Nelson, who was one of the highest-ranking Kwagiutl chiefs. There is a photograph of Alex wearing a Sisiutl headband, a carved headpiece, and Sisiutl belts. I am sure when she asked me to make a button blanket, it was because we were related through marriage to Alex Nelson. I did a Sisiutl design blanket for my other grandmother, Alice Hunt, too. She made hers out of pearl*

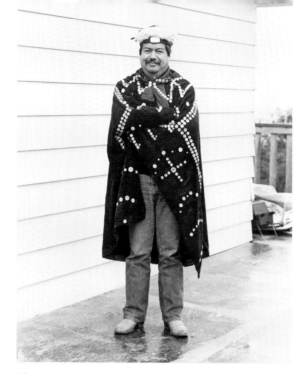

Figure 26. Tony Hunt in ceremonial regalia.

buttons and pearl beads. Alice was married to my grandfather, Jonathan Hunt, and the blanket is still somewhere in the family. They were getting ready for a potlatch of some kind, and they had probably given away their button blankets, so they were making new ones for themselves.

It was interesting when I talked to Nunu [Mrs. James Knox], and she mentioned how she made her first blanket for her daughter seventy years ago. It was a small blanket and had many small shells. She said it was not as nice as they are today. I can see where they could have been very crude, with few buttons. It was not very easy to cut them out and shape them. She said it was a big thing if you put more than one or two abalone buttons on it.

Until I designed those fifteen blankets and talked to Nunu, I didn't realize the importance of the border designs.

At the memorial potlatch, Bill Holm, who's probably been to hundreds of potlatches in our area, said, when he saw all my sisters and the new young dancers getting ready to come out

wearing the new blankets, "I'm already excited! They haven't even come out to dance yet!" He was excited by how many blankets there were—there hadn't been that many new ones all made for one dance before. That made me feel happy.

After the potlatch, I designed a new blanket. It documents the two coppers and chieftainship that I had received. What happened at the potlatch was that I was acknowledging my chieftainship. It just happened that I was of age to assume all the rights that the Hunt family own. I was given the chief's mask to wear. The main speaker, Chief Thomas Hunt, stood beside me and declared that all the rights of the family were now transferred to me from my mother's side of the family and my father's side. I also received two coppers, one from my mother's side of the family and one from the other side of the family. This new blanket will be read in front of all the people when the Big House in Fort Rupert is opened. I will tell the story of the blanket then.

Since I received the two coppers, my role has changed completely. I used to work for recognition from the elders, and now I am playing the leading role. I never considered the future any farther than my children, but that has changed now. Since I became a grandfather, my interest has increased as far as transferring knowledge to the younger generation. I want to ensure that my grandchildren will be taking part and have an opportunity to share in what we are doing.

I allowed my personal blanket to be exhibited in **Robes of Power** because my father had passed away, and I didn't have time to finish the new one.

The button blanket with the Split Raven is my main family crest, probably twofold because it is the Tlingit Raven crest and the Kwagiutl Raven crest, which was transferred to us. It represents both sides of the family, the Tlingit and the Kwagiutl. The double-headed Raven is not done too much.

Lillian Gladstone was born in Bella Bella, B.C., in 1920. For the past few years, she has taught aspects of the Heiltsuk language in the local school. During the recent cultural revival, she has helped by producing items of regalia for the Hilistis Society Dancers, and for other people in the community. She makes many pieces of dance regalia for use in potlatches and dance performances. Mrs. Gladstone's Heiltsuk name is *K'a wa'zilh*, "Carved Treasure Receptacle."

The white Thunderbird and Whale blanket made by Lillian Gladstone draws on her maternal grandfather for its crest. The crest was given to him at his adoption into a Haida clan, many years ago. The crest is used only by his descendants as proof of this old intertribal connection. The blanket was designed by her son, David Gladstone.

David Gladstone was born in 1955, and is part of the artistic community of Waglisla (Bella Bella), B.C. He specializes in traditional Heiltsuk art. David is an artist with diverse interests, creating gold and silver jewellery, wood sculptures, and silkscreen prints. He has dedicated much time to researching and recording his people's history.

David Gladstone *I first remember button blankets as being dark with red on them, and people wearing them with red paint on their faces and red headbands, looking like they weren't even from this world. When you're young, you take things quite literally. I couldn't believe the effect of the blankets. This would have been in the early 1960s. Later, I remember seeing white blankets, white sheets edged with red, painted, in use by the ladies and elders in Bella Bella. I remember dancers using button blankets, and songs being used in conjunction with the blankets, the masks, the headdress, and raven rattle.*

The first recorded sighting of a blanket in my area was around 1793 by [Archibald] Menzies, who wrote of what he saw. He describes what they were wearing. He saw a man wearing a red blanket bordered with white leather. Menzies was with Captain Vancouver, working with the charts of the coast. For us, it was a valuable document, although the description was very brief. This early person was wearing the modern button blanket, although it was red and the border was white. It was made on very old patterns. They were using leather garments decorated with painted designs and porcupine-quill overlay. In our area, the porcupine wasn't available, so they were trading from the Interior before the traders came.

Our people were really into ornamentation, and the old currency was squares of abalone shells. In prehistory, they were imported from California, and Emma Hunt tells stories of her father and family going to Japan to get abalone shells. That's how valuable abalone shells were. When these shells came in, they were sought after. They were pretty, and they had a traditional value. Besides being valuable, they were good for ornamentation, and the more you had, the wealthier you seemed to be. It was a sign of your influence, how much shell you would use.

Figure 27. Lillian Gladstone sewing button robe.

What was part of the early currency was the tanned hides, deerskin leather, white leather, and moose skin. White leather was not made by my people on the coast, but it was high in value, so they would make trading expeditions inland to obtain it. To own it was a sign of your influence, because you would have to have wealth to obtain it. The coming of the Chinese pearl buttons was like flooding the market with a cheaper form of currency. Another form of currency was the blanket. There are records of cubicles in the houses at Bella Bella, little cubicles in each side of the house occupied by people. Some of them were filled with blankets, two to three thousand blankets owned by a chief. Who knows where it all went? There is no sign today of those old white blankets.

The very first button blanket I was able to make was with the help of a foster mother. I had been in foster care at the time. I used that blanket until it was destroyed in a fire. Because I was removed from my people for quite a while when I was a teenager, I was drawn to know more about my culture. It was always my goal to be a historian and a singer. I'm not sure how early this happened: it might have been when I was seven. I knew this would be my career, one of the goals of my life, to take the leadership of the dancing system, not knowing then that there were strict rules of entry. In Bella Bella, you could not just get up and dance: you had to go through initiation and potlatches, and be of sufficient rank in the village to dance, even to the point of excluding the younger brothers of chiefs. Fortunately, I was born into a family that had the right to do things like that (which I found out later), and I did receive some training.

The late Tommy Hunt and his wife Emma discovered me, a lost boy, a boy who really wanted to know about his culture. They brought me into it. I continued this habit of being adopted. I wandered around the country, talking to elders who were very understanding of my desire to learn. Besides the elders, I went to anyone who wanted to teach me. Some would, some wouldn't. The ones that did were very generous in giving me knowledge that, to them, was very strictly guarded.

The button blanket is one form of gift, and I've received three. I received names from the same people who gave blankets. Sometimes it was names, and sometimes it was knowledge that they gave me. They also trusted me with songs for the use of their descendants.

The blanket is a symbol—a visible, tangible symbol of the giver's esteem for the recipient. The name is another gift. It's intangible, but highly valued by us. When people give you a name, it's a mark of their esteem for you. The blankets are in the same category.

Another teacher of mine, another adopted mother, was Dorothy Hawkins of Kingcome Inlet. She made me a blanket with her own personal crest, her family crest. I thought I shouldn't wear her crest, because I wasn't of her blood. She said no, she wanted me to use that crest, the Thunderbird and Sisiutl. She was more knowledgeable than me in protocol. Later, I learned that I had ancestors from Turnour Island. The reason they were bestowing favours on me and reacting so positively was that I was a relative. It was a great thing to find out.

I haven't given a potlatch in Bella Bella. I haven't gone through a passing of the blanket to me, in a ceremonial context. The only thing that's taken place in my family is memorial feasts, where dancing is not part of the program. My taking of dances (dances that have been given to me) has happened mainly in other villages, like Kingcome and Alert Bay. The dance they usually have me dance is the headdress dance. When those sort of things happen, they'll lend you a blanket or ask you to bring your own.

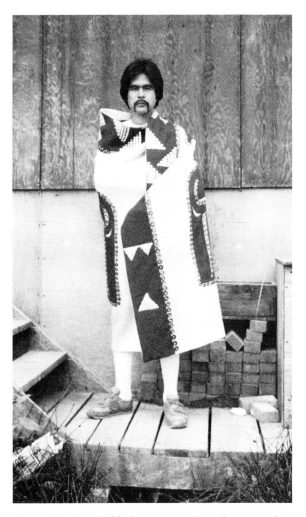

Figure 28. David Gladstone wearing a button robe.

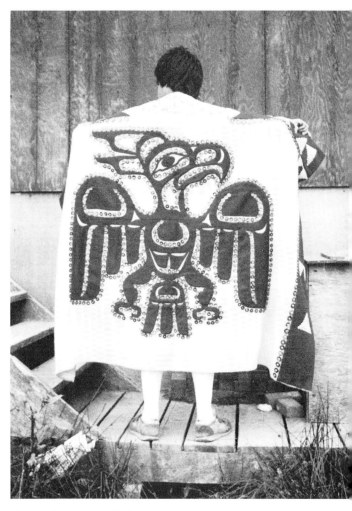

Figure 29. David Gladstone showing crest on robe.

I was given a button blanket by Chief Sandy Willie, even though I wasn't at that potlatch. I responded by giving him a blanket covered with money and jewellery at a following potlatch. I passed to his wife the right to use a Chilkat blanket. It was a painted blanket, and this was in return for having given me a blanket and many other acts of generosity on their part.

I was Chief Sandy Willie's student. He sang songs that I recorded and learned. He told me that his wife was actually a blood relative of mine on both sides of my mother's family. They gave me one blanket then, and at Paul Willie's last potlatch he gave me another blanket.

I design button blankets for a lot of people. Many of the blankets in use at Bella Bella were designed by me. Nowadays, I usually cut out the design and baste it on. I've since discovered you can tack down the design with Speed Sew [adhesive] and the sewers can go to work on it. They usually know the family crests ahead of time or they will bring it up at meetings, a meeting of elders, and discuss the crests that belong to their parents and grandparents. They take crest affiliations from their fathers and mothers, depending on the names they have received. Several names will get several crests.

The Haida dancers in Bella Bella wear white blankets because it is a peaceful dance. I like to use white even for the chief's dance. In the old days, they would have used white mountain-goat wool blankets.

I believe that the blanket colours have been dictated by what was available from the traders except for the colour white, which had special significance. It meant you were of peaceful intention and weren't going to use harmful magic or things like that. Using white meant your heart was peaceful.

There are so many ideas you can express on a button blanket. It's like a large, blank sheet of paper. You can draw and write anything on it. I think the crests were actual pictographs. They have a definite meaning that they convey very quickly, an early form of writing. You can put your clan crest on your button blanket. In our area, we put on our lineage and personal lineage crests. You put on the crests associated with your name.

I've heard of a blanket that's put on people when they first come back from seclusion. They are supposed to have flown around the world. It's a story that's been told to the people. They wore a blanket that might have been their crest, and they would have a round circle of buttons on it to show that they had flown around the world. That is unique and significant.

I've seen one button blanket that had only a round design, and I've seen another that had a round circle of buttons with an Eagle crest inside. It was a family crest of the wearer. It wasn't her personal crest: it was a family thing.

We are affected by other tribes and how they make their blankets. They are far less personal than they might have been years ago, when they went into seclusion and had time to meditate on supernatural subjects and religious ideas. They came back and had personalized blankets made for

them. Because we don't go through the ceremonies any more, there is little cause for the button blanket to be made in that way.

I wasn't in the village at the time, but a lady named Kitty Carpenter from Bella Bella of Kwagiutl origin got funding from the First Citizens Fund to make button blankets. What she used was not strictly traditional material, but dark blue material with quite a nap on it, and probably red flannel. But the shape was absolutely traditional, right down to the rounded bottom, cut out so it doesn't drag on the floor. It was more of a ladies' style: it had a border on three sides, with a piece removed in the neck area and cotton cloth placed there. The elderly ladies were making the button blankets and coming up with the exact form that we saw in an old photograph. John Humchitt's wife has one like that. She inherited it: it was a cape. We have an old picture with them wearing black capes at a funeral, cut in exactly that style, without the border. So they were using it in transition, from wearing blankets all the time to wearing clothes, and wearing blankets for dress.

I have an extensive collection of regalia that I've been able to make, purchase, commission, or trade. Some of the button blankets I own have already been validated by the families who commissioned and paid for them and presented them to me in public at a potlatch. We have a surviving ceremony, called the "dressing ceremony," where the blankets are put on, and we get quite elaborate about it. This ceremony signifies that when you take your name you change your crest, and you have a blanket made for that name. I have several blankets and several articles of regalia that I haven't shown because I haven't given a potlatch in Bella Bella to validate them. I will bring them out and announce what was paid for them and whom it was paid to, when I have my potlatch.

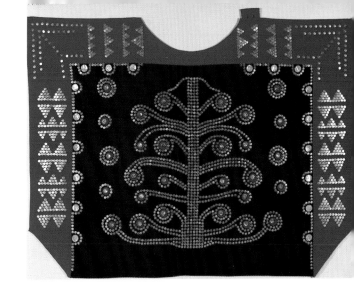

"The name of the design on this blanket is Gwa'ka'lee'ka'la, which means, 'Tree of Life.' Our use of the cedar tree is symbolized here." Dora Cook, 1985

Plate XIII

Designed by Dora Sewid Cook (Kwagiutl), 1985

Sewn by Louisa Sewid Assu (Kwagiutl)

Navy cloth, red velvet borders and appliqué plastic and abalone shell buttons

The design is the Tree of Life.

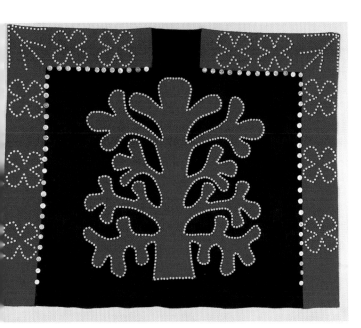

"I felt that that part of the arts was going to be forever protected.... It is just that I have always felt it was your mother's duty or your grandmother's duty to make blankets." Simon Dick, 1985.

Plate XIV

Designed by Simon Dick (Kwagiutl), 1985

Sewn by Gertrude Dick (Kwagiutl)

Black melton cloth, red border and appliqué, white plastic buttons

The design is the Tree of Life.

"The blanket keeps him alive: it keeps them all alive! When I see the blanket now, I think, 'There's Dad, with his hand out in friendship!' " Marion Hunt Doig, 1985

Plate XV

Designed and sewn by Marion Hunt Doig (Kwagiutl), 1985

Navy and red wool, abalone shell and pearl buttons

The design is the Thunderbird created in memory of her late father, Chief Thomas Hunt.

Figure 30. Joe David

Joe David was born on Meares Island, B.C., in 1946, but grew up in Seattle, Washington. In the late 1960s, while working as a commercial artist, he began to take a serious interest in Indian art. At the University of Washington, he attended classes given by Bill Holm, a well-known Northwest Coast Indian art scholar, who encouraged him greatly. Joe David returned to B.C. and continued to increase his knowledge of Westcoast art. He has produced a number of highly prized silkscreen prints. His masterly wood carvings are in many public and private collections. Joe David is currently using his art to promote a greater understanding of Indian culture.

Paula Swan was born in Auckland, New Zealand in 1950, and emigrated to Canada in 1971. She and Joe David have made a number of blankets, some of which have been exhibited or collected by museums. They worked together closely on this particular blanket while preparing for the birth of their daughter, Marika, in the summer of 1982. Two mating whales are depicted, chosen to represent the inheritance and power of Joe David's family crest, and to symbolize the union of male and female and the creation of families. Marika Echachis was born on the little island of Echachisht, the same place where the last whales were brought in about 1907.

Joe David *I was born in 1946, on Meares Island. I was born into a period of strong cultural influence, potlatches, old artwork, and the old-timers from the last century. My father was a speaker, dancer, singer, and carver, so I was influenced towards the art and culture. Today, my art work is not only for commercial use but also for native use, for friends, and I do a lot of trading.*

My father is from Ditidaht. His name is Hyacinth David, and my mother is Winnifred David. She was Winnifred Hamilton from the Port Alberni area. Ron Hamilton's dad and my mother are brother and sister.

We have several crests. The most important is the Wolf, which belongs to the Westcoast people, but there are others like the Killerwhale, the Thunderbird, the half-Wolf/half-Whale, and, very important from the Nitinat side, the Blue Star. I have yet to ask the elders and the Nitinat the significance of the Blue Star. It has five points, but I have a feeling that in the old days it had four points.

In 1981, I received the two-headed Eagle crest and other subcrests from Robert Davidson when he gave a potlatch in Masset. He also gave me a name, songs, dances, and a button blanket. So I have an official ceremonial button blanket from the Haida people. The design on the blanket is the two-headed Eagle, and on the borders is appliquéd a design of four faces which represents "spirits rising," because the Haida name, Skilk'aahluus', which he gave me means, "Wealth spirits rising."

In the old days, they wore short cape shawls and the longer shawls made from red cedar bark and yellow cedar bark. A lot of them were trimmed with sea otter on the collar and hem. I haven't seen any of these cedar bark capes with designs on them, but there could be on some of the old ones in museum collections.

I did not see button blankets, as a child, around the village. What I remember seeing were capes. They were made from muslin cloth or canvas-like material with painted designs. Some of the capes were just regular blankets, too.

What was very popular through the 1950s, 1960s, and 1970s were capes, with sequins rather than buttons, and some with the designs painted right on the cloth. When these capes are done well, they are really effective. I like some of the black capes with sequins and fringe: they call them "shawls." A lot of the older women like the shawls.

In a lot of cases in the old days, when they danced to give away money, they wore blankets, and on them would be sewn eagle feathers or money, safety-pinned on, that they were going to give away. It was worn during the Serpent Dance. Immediately after the Serpent Dance, they gave away the money.

I have seen a few button blankets at potlatches recently. And I've seen old photographs of the chief's family with button blankets. Back then, the Joseph family had button blankets at Opitsaht.

Ron Hamilton (*Kike-in*), Westcoast, was born in 1948 at Aswinis, a small reserve in Barkley Sound on the west coast of Vancouver Island. He went to school in Port Alberni, Terrace, Campbell River, and Victoria. He began drawing and painting designs in elementary school in Port Alberni. In 1969, he moved to Victoria and worked there at the Provincial Museum as a carver until 1974, when he returned to the Alberni Valley.

Since 1964, Ron has been doing extensive research on Westcoast Indian history. He continues to document the songs, dances, and history of his people. His artistic talent is seen in his sculptures, jewellery design, photography, and in his silkscreen prints, which are available through galleries and shops. He is an accomplished carver of traditional masks and rattles.

Ron Hamilton *During the last five years, most of my leisure time has been spent concentrating on song and dance. I have composed many songs, and have given performance rights to some of them as potlatch gifts.*

One thing I'm doing now is researching Westcoast screens and Westcoast ceremonial robes: these have to be some of my favourite topics. I think there is a connection between screens and blankets. They both have representations of creatures that are crest figures and have to do with the history of people's families. Westcoast blankets and screens have a lot of images that represent generations rather than a single generation. When marriages are involved, crest figures come from different places, more like a family tree, so you get a lot of history wrapped up in a single blanket. Most button blankets that I have seen have a single figure. They seem to concentrate on the one figure.

On 12 November 1983, with the assistance of my extended family, I hosted a potlatch to honour my sons, Jacob, fourteen, and Johnson, twelve, and gave them certain ceremonial rights.

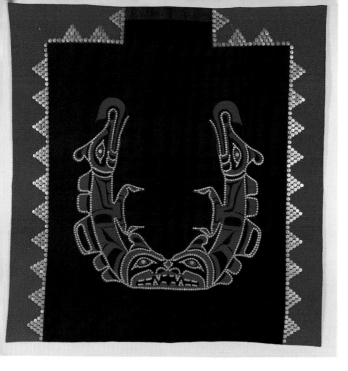

"My daughter plans to get married, so I asked my father if it is appropriate to make her a button blanket to present to her on her wedding day." Shirley Hunt Ford, 1985

Plate XVI

Designed by Richard Hunt (Kwagiutl), 1985
Sewn by Shirley Hunt Ford (Kwagiutl)
Green wool, red border, plastic buttons
The design is *Sisiutl*, the two-headed serpent.

"If I don't have a button blanket on, I feel incomplete. When I have one on, it changes my feeling, and then I'm one hundred per cent confident with what I'm doing. I think about the responsibility that's placed on me. I feel a closeness with my ancestors. I feel a spiritual strength." Tony Hunt, 1985

Plate XVII

Designed by Tony Hunt (Kwagiutl), 1974

Sewn by women members of his family

Navy melton cloth, red border and appliqué, white plastic buttons

The design is Split Raven, a Hunt family crest. This is Tony Hunt's personal blanket, and was made in 1974 for a memorial potlatch for his mother, Helen.

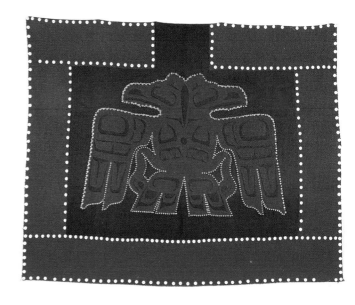

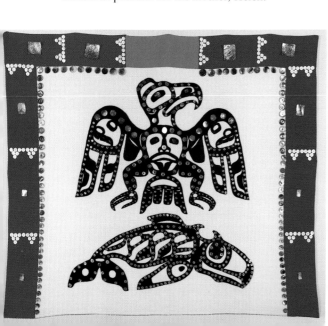

"The colour white ... had special significance. It meant you were of peaceful intention and weren't going to use harmful magic or things like that. Using white meant your heart was peaceful." David Gladstone, 1985

Plate XVIII

Designed by David Gladstone (Heiltsuk), 1985
Sewn by Lillian Gladstone (Heiltsuk)
Old white woolen blanket, red and black melton cloth appliqué, smoked and natural mother-of-pearl buttons and abalone squares

The design is Thunderbird and Whale, Lillian Gladstone's maternal grandfather's crest.

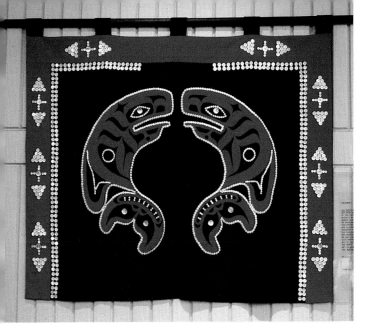

"I was born into a period of strong cultural influence, potlatches, old artwork, and the old-timers from the last century. Today, my art work is not only for commercial use but also for native use, for friends, and I do a lot of trading." Joe David, 1985

Plate XIX
Designed by Joe David (Westcoast), 1983
Sewn by Paula Swan
Navy with red border and appliqué, buttons
The design is of two Whales.

"Westcoast blankets and screens have a lot of images that represent generations rather than a single generation. It's more like a family tree, so you get a lot of history wrapped up in a single blanket." Ron Hamilton, 1985

Plate XX
Designed and painted by Ron Hamilton (Westcoast), 1985
Sewn by Sharon Anne Marshall
Unbleached muslin painted with acrylic paint, dentalium-shell decoration
This Westcoast dance robe represents an account of some of the privileges bestowed on Ron's two sons on the occasion of the 12 November 1983 potlatch.

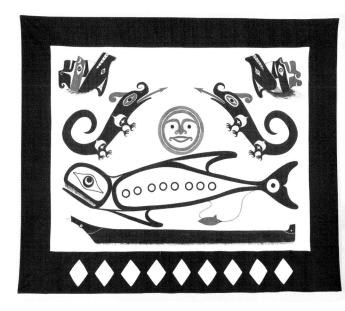

The following is a description of the Westcoast dance robe that represents an account of some of the privileges bestowed on my two sons on the occasion of the 12 November 1983 potlatch.

This Westcoast dance robe is constructed entirely of unbleached muslin. All the border segments have been coloured using black aniline dye, readily available in most department stores today. The bottom border has had nine diamond-shaped windows cut through it, exposing the contrasting white background material. In the past, diamonds and triangles were used in decorative border motifs on ceremonial dance screens, used as backdrops during potlatches. The woman responsible for sewing this dance robe is Sharon Anne Marshall of the Kilthsmaa-ath.

The designs were painted using "Hypar" acrylic paints, Mars Black H134, Portrayt (red oxide), India ink, and a bright blue paint made from varnish mixed with powdered chalk. The designs represent, from bottom to top, a shitlats or freight canoe; a nondescript baleen whale with an exaggerated dorsal fin trailing a tukwakimlth or sealskin float; a round central face representing Kike-in, the head chief of the Hiikulthath; two serpents with harpoon-like tongues; and two men wearing crawling-wolf headdresses.

About to receive names, my sons were escorted from behind a ceremonial curtain by two crawling wolves. The designs in the uppermost corners represent those crawling wolves from the house of Aktiisath. They brought two supernatural crystals and two names with them.

The blue-rimmed central face represents Kike-in. I received the name Kike-in at the same potlatch, and his face appears on the dance robe to remind the one wearing it of their ancestral roots. It is meant as a source of strength. The halo surrounding his face is decorated with hayxwaa,

dentalium shells. This type of decoration was the precursor of pearl buttons.

The two predominantly black serpents represent the last ceremonial privilege shown at the potlatch in the boys' honour. Their potlatch was closed by the display of a serpent dance from Hiikulth. These serpents—Hayiitlik—are the harpoons of the Thunderbirds.

The long baleen whale represents all the whales successfully harpooned by Santo, a younger brother of Kike-in. The name Santo was bestowed on my son Johnson.

Lastly, the large freight canoe is of the type used by all of the Westcoast tribes prior to the arrival of power boats in our waters. These large canoes were often tied one to another, then covered with planks to make a platform. All household utensils, personal effects, and family members were loaded on the raft and moved slowly from one seasonal camp to another by men paddling along the two sides. Jacob, my eldest son, received the name Kwiispiisiis, which means, "Travelling back and forth between two villages." The canoe is meant to bring that to mind.

Recollections of Historians

Agnes Cranmer
Born: 1908 in Fort Rupert, B.C.

I had my first button blanket when I was ten years old: it was the Sun design. This crest came from my father's side of the family, the Fort Rupert side. I received it from my great-uncle—when I recognized a blanket he had made, he gave me the Sun crest. He designed it, and his wife made it. Then I had a green one, with a big abalone shell. It was the type worn as wedding regalia. If potlatching had been permitted, one would have dressed in a button blanket or carried a copper or worn a robe with a big abalone shell. I was very lucky to have that.

In 1958, when I was going to Nanaimo to see the Queen, my friend, Mrs. Hawkins, helped me to design a blanket with a Thunderbird in the centre. We placed little mountains on the border, and we used old pearl buttons called "water pearls." The material was just an ordinary blanket. I made blankets for my grandchildren, Vera's children. I asked my grandchildren which one they wanted, the Eagle or the Thunderbird. They liked to have the Thunderbird. I have crests from my mother, father, and my husband that I can use.

My son, Doug, is a good designer. You could come to him and pay for a design to put on a blanket. My friend, Ethel Alfred, had Blackie Dick make her design. You can tell this man what to put on that blanket. You have to be particular about the details. You just use the things which belong to your people.

I always remember to put a blanket away inside out, as I remember that is what we used to do. For some dances, too, like the Ghost Dance, you never use your blanket right side out, it has to be inside out. Another dance, the hamatsa, *you use your blanket inside out. If you danced a woman's dance, then you would use the right side with the buttons showing. Since I started making button blankets, I have made almost fifty!*

I sold one of my button blankets. It was the Sun design, and I sold it to the National Museum. I am sorry I sold it. I would rather have kept it in my family. People come around and want to buy this and that, and I say we still use that. Especially the head pieces for the Welcome Dance. The Bella Bella people call it the Chief Dance. It is worn to welcome the people.

Figure 31. Agnes Cranmer holding dance apron with Tree of Life design.

Plate XXI Opening celebration for **Robes of Power** exhibit at the UBC Museum of Anthropology, 7 March 1986.

Plate XXII Student working on robe.

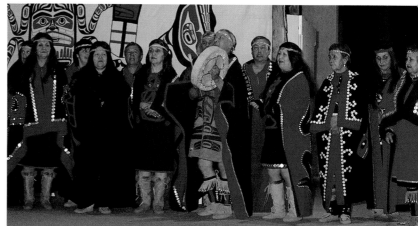

Plate XXIII The People of 'Ksan celebrating the conclusion of the children's button blanket workshops at UBC MOA, 1 May 1986.

Plates XXIV, XXV Vancouver school children in their completed robes with instructors Dolly Watts (far left), Marion Hunt Doig and Margaret Heit.

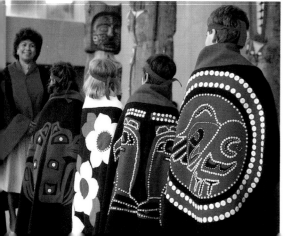

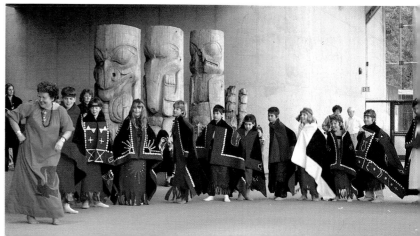

Martha Brown
Born: 1901 in Glen Vowell, B.C.
(Translated by Margaret Heit)

In the old days, they used black gwiis maawsw *(literally, "covering white") to make button robes. The olden blankets, the ones the Hudson's Bay used to sell, we called* gwiis maawsw. *Some were white, some were black. They had different colours. It was at the Hudson's Bay that they found them, the first Hudson's Bay, out at the coast, at Port Simpson. This was where they found the blankets, the material. Some people went toward Vancouver and found plenty and bought many, as they were not very expensive, about $1.50 each. They used them at the feasts. They'd tear them in pieces, four to each blanket, to be used inside your moccasins. You wrap your feet in the blanket pieces, then step into your moccasins.*

I don't have a gwiis gan m'ala *now. I keep talking about getting one made. There will be wolves on it, and an opening [circle] below the back of the neck … a round thing, round and red. It will have the crests in the centre to represent the family clan, the* wilp *[House]. The border area will be red. The blanket will be black where the wolves will be placed, where the crests will be placed. Nothing at the bottom or here [the front borders]. A member from the House of* Geel *will make it for me.* Geel *looked after me for a long time when I was small. Cared for me like a father. This is what I shall say when I put on my blanket [at a feast, to validate it].* Geel *raised me to adulthood, and this is why I have chosen one from* Geel's *house to make my blanket.*

Before the feast of the Wolf clan she gives it to me, and I pay her at the feast.

I first saw a button blanket at my uncle's—a button blanket and a medicine-man's robe. The design on my uncle's button blanket was also on his ceremonial leggings. They placed the Wolves like this, properly standing. See what they do now, the Wolves are like this [not realistic], and the

opening is placed in the centre of the back of the blanket.

"When the opening is" is what my grandfather's house was called. Hlii yeem lax Ha, "He who crosses the heavens," house had a round opening and looked as if it was the sun. This is where the chiefs entered. They built ladders up and then down into the house.

Whoever knew how made the designs for the blankets. The late Elizabeth, wife of Albert Tait, was the one to make button blankets in Kispiox. I saw her. It took her a long time. They used large buttons. I believe that the robe was for herself. She used a Frog insignia, and the little Frogs were positioned to meet in the back of the robe. The Frogs didn't stand up, like now. The Frogs are laid back, with legs apart. They used it when they had a feast. When they first showed that blanket, money was not passed at the feast. They used tanned hides. The old people never had money. They used tanned hides in place of money. The sewers softened and made the hides. It takes so long! It's no fun.

I never made a blanket when I was young. We only sewed buttons on. We'd gather when they were going to make a blanket. When the late Marion Skulsh was doing one for which the Tsimshian women cut the pattern, we sewed the buttons on, with real thread. They got it from the same place, down at the coast. They, the Port Simpson people, brought the cutout designs and exchanged them for dried fish and processed fish eggs [fish eggs matured like blue cheese]. It's Indian caviar!

They gave the blanket to whoever owned a crest similar to it. Later, at a feast, she would get four or five tanned skins as payment. The persons would buy the tanned skins previous to the feast.

Before Geel's *pole was raised—"The Big Snake"—Mom and them went to Houston and bought forty really nice skins* [*hides*]. *The skins were not expensive then, only two or three dollars. They would load up potatoes to exchange for the skins. They used the wagon then. They didn't have cars, nor were there any buses.*

Before the pole raising, during the night, we heard what sounded like singing, and I recognized Geel's *song. I said to my uncle, "Listen." He said, "It is the spirit* [*singer*] *walking around because a pole is about to be raised." He came all the way from Kispiox and he walked through here* [*Glen Vowell*]*, and he walked to Gitanmaax. This is the old law of the Indians. Now we don't send someone around to announce a feast, we only dial the phone.*

Anyone that uses the names uses the button blanket. Like when my box [*coffin*] *is about to depart from here, the blanket will be draped over and taken off and put on the person that will use it, and that person will leave the house ahead of my casket. This is how the old folk did it. They don't do this any more: they use the church.*

Only those with important names had button blankets. Only a head chief will wear the gwiis halayt. *One chief sat on either side of* Geel, *and these three are the ones that wear the button blankets. They don't make a fuss about ordinary people. They sat at the end of the house after the important people were seated.*

With the button blankets, they wore only the cedar neck rings. It was the law of the Indian in the olden times. The chief, the one who was head of the house, wore a wide one, very wide. It shows he has passed all the tests to become a chief.

Florence Davidson
Born: 1896 in Masset, B.C.

Before I was born, they did away with all the totem poles, just one standing by the road, a great big one. I saw a few others, too, but I don't remember where. The minister came around and made everyone cut all the totem poles down and burn them. Some houses had three totem poles. The minister called it "their gods." But it is not, it's to let the descendents know who they are. They didn't want to marry their own clans. That's why they had crests on the poles. Eagle clan and Raven clan are supposed to marry, not Eagle clan to Eagle clan.

The button blankets have our crests on them too. My husband's crest is the two-headed Eagle, and mine is the Raven. My other crests are the Shark, two-finned Killerwhale, and the Brown Bear.

My grandmother didn't make button blankets during my time. When they were young, they had them. They didn't make them after the minister came around.

My ancestors lived on North Island. My grandfather was chief at Kiusta, which is near North Island. He was a sea-otter hunter. My mother said he used to get lots: she used to go where the furs were hanging. She would go there and blow on the fur, and it looked just like silk. They used sea-otter fur for capes and to dress up in the olden days, not for every day. When they had their doings, that's when they dressed up.

My mother never used to make them [*button blankets*]. *She used to work on root. She made hats during the winter. We would get the roots in May. She would tell me not to go with her, but I liked to help her. I knew that if I could work hard for her, I wouldn't have to go to school. Every morning, before the sun came up, we would go for roots. We would stay out there all day. My mother would get the big roots. She carried them*

on her back. After that, she would put them on the fire and singe them on both sides so she could pull the skin off.

Sometimes my mother mixed bread dough at home and we would take it out to where the roots are. When she made the fire, she would bury the dough under the red-hot gravel to cook. We ate it with butter and syrup.

In 1951, we lost our home and all our possessions in a fire. My husband and I went to Vancouver and bought a whole lot of household goods and clothing, which we left in our fishboat until we were ready to go back home. The boat was broken into and everything was gone again. I felt bad: what little I had was lost. All of a sudden I said to myself, "Make a button blanket to make yourself happy." I bought some navy material, some red for the border, and boxes of different sizes of pearl buttons. The buttons used to be cheap, so I bought lots of them. When we came home, I went to a carver and said, "Can you make a Bear design for me?" This old man, he made a design and it looked like a dog lying on the ground: I didn't like it. Then I came home and showed it to my husband. "It doesn't look like a Haida design," I said. My husband said he would try to make the Bear design for me.

It was the first blanket I made. In the olden days they just put buttons on, but I can't do it that way, so I have to put red underneath it and lots of pearl buttons. I make my borders different to make them look pretty. [Instead of placing two rows of buttons side by side, Florence alternates her two rows of buttons.] They put three borders on the button blankets to make them hang nice. Some people put a border on the bottom now: I don't like it. I was hiding while I was making it and I worked on it for two years. When I finished it, I showed it to my oldest sister. She started making

Figure 32. Florence Davidson speaking at the opening ceremonies for the Robes of Power exhibit.

them too. Virginia, my daughter, has the blanket. I gave it to her because it's the first one I made.

When the salesman came around, he bought all the blankets, cheap. But he didn't get mine: Virginia had it. He said, "I heard that you got lots of your dad's bracelets." And I said, "Yes, I have. You can't buy it from me. It was made for me, for all my life. Even if you paid a hundred for it, I wouldn't sell it to you."

When my daughter, Emily, graduated from high school, I gave her a button blanket, and when Clara graduated as a nurse, I gave her one too. She don't wear it.

Robert [Davidson] makes all the designs for us. He makes designs for Aggie, and she makes button blankets.

My husband gave our grandson, Robert Davidson Jr., his button blanket to wear for a totem-pole raising. I made a plain button blanket for my husband because he was in a hurry. I promised to make him a better one, with lots of shell buttons, after the pole raising. He took ill shortly after the pole raising and gave his plain button blanket to his niece, Hannah Parnell, because he didn't want her to be without one. She was so happy with it.

I gave Mr. [Prime Minister Pierre] Trudeau an Eagle-crest button blanket, but it didn't match his name. I made him the Raven-crest button blanket in a hurry when I heard he was coming here. He was happy with it. We traded. I told him, "You have to send the other one to me." He did, and I gave it away to the museum in Skidegate because I didn't want to keep it. I felt like I was being stingy.

They thought I was dying last spring [1984], that I wasn't going to live, so we celebrated my ninetieth birthday. I told them, "Why don't you wait until next spring, when I feel strong?" There were about five hundred people there, one hundred and ten at the head table. It was real nice.

When I got sick, I promised Virginia all the roots I had. When I got better, I wanted my roots back. We laughed together so much. "It's all right, Mom, I can get my own roots," she said. I can weave now. I must keep my roots. My daughter Aggie always comes down and gets my roots and cedar bark for me.

David Gunanoot
('Ksan Historical Research Files)

I am Muut and I am N'ii K'ap. I have two blankets. W'ii K'aay had a blanket too, I think, because they were both the same height [rank]. I don't know why there are no buttons in the neck area of the robe. I didn't ask the question about that from my mother. Long time ago, they didn't have the materials to make those things. The Big Shot [fur trader] come in and they sell the blanket—chief's blanket [fur]. That's why they decided to make the gwiis gan m'ala [button blanket]. They order this [indicating buttons and appliqué]. Those cost a lot of money! That's what they say.

The button blanket is to be on the coffin. Look at what they did to my mother's coffin. There's two of them, two Kispiox [men] ... they take that blanket off the coffin and they walk back, and they hold the blanket like that [demonstrates that the whole blanket is displayed with the crests toward the congregation]. They get the coffin outside. That's the time they come over and they gave that button blanket to me. I'm the one to look after it. I know what that means! I heard that a Port Simpson fellow, he sold his to the United States to get a pole. He makes his pole, but, no power He lost it all.

Remember the time when the big Ga dim gal doo pole down by the river was raised? I got to wear my button blanket for the main part of a main thing. I wear it only at that time. I use it for a guarantee on anything which is right. It was right for those people to get the pole. That's the only time I wear it. Mother keep it very nice ... and safe.

The blankets have to be real red and real black. I didn't ever ask the people who made those. It's like that, and should always be the same. The button blanket is regalia to show who is head chief of the House.

Years and years ago, the big, cedar neck rings [luux] ... they go with a button blanket. The bigger the cedar neck ring they got means many potlatches to get that big.

A long time ago, before a big potlatch, when the t'ets [invitation bearers] went out and were entertained in the villages, they would wear button blankets when coming to the house.

I was talking about that tree with the marten [one of N'ii K'ap's crests]. That's the power. The old power ... the new person looking after the power of the head chief [pointing to photo of himself]. For many years, that's how it is. Look at me, the only one left, and I got all the power for my wilp [family]. The old people didn't get power without the groundhogs, caribou hide, moose hides, and bear hide. They hand up the hides. They put them up and, "Here we go!" [The potlatch begins.]

Figure 33. David Gunanoot at 'Ksan Village.

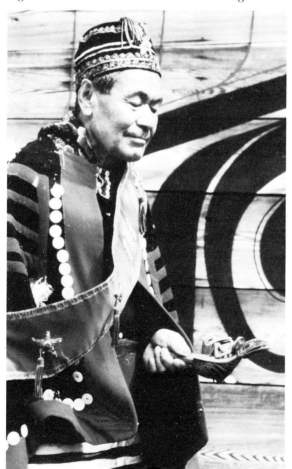

Moses Ingram
Born: 1907 in Masset, B.C.

I am seventy-eight years old and I was born in Masset. My mother was born in the village that they used to call Yan. They called it Cheech, and so they were called the Cheech people. We have a big reserve there.

I saw a Juskatla blanket in Hydaburg, Alaska when I was a young child. The background of the blanket is black, and the design was almost white and made by hand. They wove the designs out of wool. It looks pretty. They call this blanket naax-heen [Chilkat robe], which is in the Tlingit language. My mother used to talk about it all the time. Naax-heen was an old blanket. They made them in Alaska.

They say that they used to buy fancy buttons from the Russians at Sitka many years ago. They were mother-of-pearl.

No one knows where button blankets come from. They just came naturally. I did not even hear from my grandmother where they came from. Before I was born, everybody started to wear them. There are all kinds of designs on the back—the Eagle, Killerwhale, and many more. My crest is the Eagle. When we dance, we turn around and show the designs, so all know what crest we belong to. It is very interesting.

In front of the longhouses, they used to put the crest. If you belonged to Killerwhale, they would put that on the front, so they would know what clan you belonged to when they first saw you. That is why they used to do that long ago, even on totem poles. When you see the Eagle standing way up on top of the totem pole, you know to whom the pole belongs. See that Eagle up there? That belongs to me: that is my clan.

Flossie Lambly
Born: 1906

I was four years old when we went to Masset. I remember they had a potlatch. They had a ceremony and I didn't know what it was all about. That's the first time I saw button blankets. They were not used very much in those days, because the missionaries were trying to make them leave their Indian ways and live like white people. The missionaries discouraged the people from using their button blankets, masks, and everything, so there weren't many button blankets around.

Sea otter is what they used for the robes mostly. You put the fur side next to your skin, and the skin side was worn on the outside. They had some way of putting a blue dye, curing it: they would rub it in. It was a rock, sort of royal blue. They would pulverize the rock and mix it with some kind of oil, rub it into the skin of the animal, and it turns into a deep blue. It tans it, preserves. So the robes that the nobility wore were these black things with the blue skin. That was the original button blankets.

They bought the dentalium from the American coast. At low tide on the Charlottes, they found dentalium in certain places. The dentalium was scarce. The Indians down there would trade them something else. They used it like money. They brought home lots of dentalium shells. You could buy other things with it. That was even before the white man.

Mother said the women made the button blankets. But the men made the buttons before they got the white man's buttons. They would get some kind of shells and break them into oblong pieces. They would put their thumb on it and hit it with a sharp point like that. You can get a piece as big as your thumb, then drill holes in the centre to fasten them with.

The button blankets were dark, navy blue or black. The red trim was red flannel. Some had shells and ornaments made from shells. Some of the shells were round, oblong and twisted. The twisted shells were dentalium, and considered valuable. The Haida bought the shells from the people of the Oregon coast. They would go there in their canoes. I've seen blankets sewn with those shells made into a design.

At the potlatch, I remember my mother wearing a button blanket, but it wasn't hers. It belonged to her uncle, and she was entitled to wear it. She was very annoyed because they put paint on her face. It was black and red streaks, and she didn't like it. She enjoyed wearing the button blanket because there were so few of them there at that time. The button blankets had been sold to people from the museum. That was in 1910 at Masset.

The potlatch was for someone who had died, and they were going to name his heir. They invited everyone from the village, and people were given their names. If you wanted to give your child a name, you would go to this potlatch. The Indian name I received means, "She whose voice is obeyed." You were given the name in front of witnesses and that made it legal, because they had no written language. Whatever they did, they did in front of witnesses to prove that it was done.

My mother's uncle was the Eagle chief at the time. He was from the Weah House, and his main crest was the Eagle. The totem pole with the Beaver at the bottom and the Eagle on the top was the Weah crest. The original Weah's father was a Port Simpson man, and his crest was the Beaver: we have it on the bottom of all our totem poles. He is the foundation of the family, and we are all his children from then on. One of our totem poles has the Killerwhale, and it belongs to my maternal grandfather. The Eagle belongs to my maternal grandmother. One of our lesser crests is the Hummingbird. The totem pole is like a family tree.

I remember when I was eight years old and we went up to the inlet on the Queen Charlotte Islands. The inlet was called Watlin River, and it was across from Iron River. My Auntie Florence [Davidson] and her husband, when they were quite old, would still go there and fish. Robert Davidson goes back there every spring, and he loves it there.

There is always a good storyteller in the crowd. We'd all gather at a campfire and listen to the stories. We would have singsongs. They encouraged the children to sing. Once in a while, someone would take a notion to sing something comical. It was great entertainment. They sang Indian songs.

The old people, usually the grandmothers, would teach them, sing for them, and beat the drum. They would teach them how they would dance in the old days. They showed them how to do it.

My grandmother would storytell and sing. She was the official babysitter, and she would keep us busy while our parents were away. She would make pointed hats out of skunk-cabbage leaves. Sometimes she would take towels or flour sacks and make cloaks for us. She would dress us up and show us how to do all these dances of the old days. She was a great one for teaching us how to dance and sing. She said, "Always remember who we are." She would tell us the histories of all our people, and tell us over and over again. "Remember your family history," she would say. We didn't have a written language, so we had to depend on the old people telling us.

In the old days when they lived in those big longhouses, they had cubicles for bedrooms. Sometimes they had blankets hung up to form the cubicles. The one who had the cubicle next to the chief was an heir. A cousin would have the next

room which makes him "a blanket away" from becoming the chief. So that's where that saying came from.

I was really pleased when Florence Davidson started making button blankets, because I thought it was a pity that they [the old robes] were sold. They were so beautiful.

I was really thrilled to think that people were going back to what it used to be like. In my generation, everyone was trying so hard to be like the white man, and they were giving all this up.

When I was a child, I was so impressed with the button blankets. They were so beautiful! When we were little kids, after the potlatch, my cousin, my sister, and I would play and dance. We would get towels and put them over us. We would pretend they were button blankets and dance. I asked my mother, "Why can't I have a button blanket?" She said, "Only the chiefs wear them. You are not a chief. You can't have one."

Figure 34. Flossie Lambly

James Sewid
Born: 1913 in Alert Bay, B.C.

I lived at Turnour Island with my mother for a few years: we lived in a big Indian house. My father died before I was born, and my mother married again. She married the chief of the Turnour Island people, John Clark. He was a very good man, and I always thought of him as my father. I was about five years old when he died.

As a child, I saw a lot of button blankets. There would be hundreds and hundreds of them hanging up in the big Indian houses [during a potlatch], with designs on the back. They used a lot of beads on the blankets—small beads which were very beautiful and fancy. I never did see them making the button blankets. Even small children had them. I saw young kids with button blankets all the time. There was a special dance for the little ones. This was a dance where the mother would wrap their babies in blankets and carry them in their arms while dancing. When I was young, I had a button blanket.

Figure 35. James Sewid

One of our dances is the hamatsa, *the wild-man dance. My grandfather had a black-bear* hamatsa *robe. Some* hamatsas *like to make their blankets fancy. I don't know where they get this idea from. You are supposed to announce in public where you get your blanket from. When I was initiated into the* hamatsa *society, I wore a Chilkat blanket. I had to announce where I got it from and why I had the right to use it. No one else could use it unless it was inherited or given in marriage. If a* hamatsa *did not have a black-bear robe or Chilkat blanket, they would just turn their button blanket inside out, because they did not want to show the buttons. By that time, I don't think anyone had a real bearskin robe. At one time I owned my own Chilkat blanket, but my uncle sold it. It was called* ya'yak'sum. *These blankets were worn by chiefs. You can't just use a blanket: you have to inherit it. Blankets and other regalia would be passed on to the sons of the families.*

The blankets used for the kla'sa'la, *which is also called the feather dance or the peace dance, would be adorned with abalone shells. These blankets were used for the more important dances. They were worn by people of nobility.*

When the hamatsa *wears cedar bark headgear, they become peaceful and not wild. The cedar was dyed red, and we call this headgear* kla'qouq. *For the other dances, lower in rank than the* hamatsa, *they would mix the red-dyed cedar bark with the yellow cedar bark, and we call this* ka'jouq. *The yellow cedar is the natural colour. It looks real nice mixed with the dyed cedar bark. The weaving of these would be very fancy.*

When a person was just being initiated into the hamatsa *society, he was required to always wear the pure red cedar bark headgear. He was not allowed to take it off. The reason was so people would know you had been initiated into the* hamatsa *society.*

Albert Tait
Born: 1901 in Kispiox, B.C.
(Translated by Margaret Heit)

My father said that recently, I believe he meant since the white man came among us, they made their ayukws [*individual family crests*] *of cloth and placed them on the blue-black blankets, the* gwiis gan m'ala. *These are the ceremonial robes they use when the deceased goes up, they say. They tell this about the button blanket: for each House, the blanket holds the trapline, the hunting grounds, the berry-picking places. These a chief's* gwiis gan m'ala *covers. This was the law in the past, and it is the law today. Nothing has changed. A chief does not lay claim to another's grounds. In the summer, those that had no fishing grounds were invited to live alongside the chief's family and prepare enough food for the winter. Our father said that all these laws are on the* gwiis gan m'ala. *The figures on the* gwiis gan m'ala *are not just a design. As does the totem pole, the* gwiis gan m'ala *holds the laws of the Indian people. In the past, only the descendents of the chief could use crests.*

I am the head chief in our House. I am not chief to anybody else, only this House. A long time ago, only the main chief and the chief to his right and left [as seated traditionally at a feast] wore button blankets. The others wore groundhog robes.

Now, I don't have a gwiis gan m'ala. *I should get someone to make one. We have many crests for it, the Raven, the Beaver, the Canoe that* Luutxesxw *used to come home. I will show my new robe at a feast. The chiefs from Kuldo, the first chief, will put it on me. It will cost me money. After I have shown my* gwiis gan m'ala, *I would wear it again only at events of the greatest importance.*

The blanket is not used for events such as a wedding. When the news comes of the death of another chief, then the chiefs may wear their robes to the funeral of one of them. This is an important time, and they wear their gwiis gan

m'ala. *Their law is on the* gwiis gan m'ala, *and they blow the eagledown, so that trouble will not come.*

The robes would be worn for a totem pole raising. Before the pole is raised, the chief stands and sings the Breath Song. It is only recently that they do not sing the Breath Song, only the mourning song, the limx oo'y. *Also, when the* t'ets [*invitation bearers*] *arrive in a village and are feasted, the chief of the other village performs the* halayt *dance, wearing the* gwiis gan m'ala, *and puts eagledown on the visitors. It means he will attend the feast to which the* t'ets *are inviting him.*

It is said that only recently they put buttons on to beautify the blanket, and this is why they call it, "robe with buttons." On some old, old blankets there's only the crests, no buttons. Like I said, it looks nicer with buttons, hence, "robe with buttons."

I don't personally know when they started to use cloth. I would not want to be mistaken. I was fortunate enough to have my grandfathers to teach me, and only what I heard will I pass on. I know that the people changed to blankets of cloth after the white man came. It was then they put the crest on the robes.

My wife helped make button blankets. They [people of Kispiox] bought the designs from a Port Simpson lady. They cut red material from the design to show up on the black material.

I never saw the tanned hide ritual blanket, but I was told about it. When my maternal uncle put up that totem pole over yonder ... when the pole was up, after they disbursed the gifts, then two people held up the plain, tanned hide, and they pro- claimed the names of the deceased chiefs in the same House that is raising the pole. They sing the mourning song, and the deceased are on their way up.

Contributed articles

Sculpting on cloth Dorothy Grant

When I'm working on button blankets, I feel that I'm "sculpting on cloth," my scissors being like a chisel and hammer to a sculptor, defining every line with a precise cut. If a cut is not clean, you affect the whole design. It is very important to accentuate the design. Buttons should be evenly spaced to allow the creature to flow. In formline design, there are major parts of the body which must be accentuated with buttons, and some are only secondary parts. I try to concentrate on each part, but always keeping in mind the balance of the whole. Many times, I will only appliqué, instead of putting buttons on every line. If there are small negative spaces, I sometimes place small beads there in place of buttons. If there are many lines, I like to define by fine stitching.

When Robert [Davidson] started designing button blankets for me, he decided to do something different by designing the borders. The usual borders are six inches. I like to think of the borders as one of our main crests. I put our main clan crest on the borders. When the blanket is worn, it comes around and the border is shown in front, so you see the clan in front and family crest on the back. You are covered all the way around. Although the stitching takes so much time, the overall effect is where it shows. Robert and I consult each other about patterns and button placement. Sometimes he puts much more detail into the designs, particularly this one for the **Robes of Power** show. When we work jointly on a blanket, it probes our creativity. Robert is challenged to do a good blanket design, and I am challenged to make that creature as strong as possible. It requires respect for one another's talents, that's the good thing about working together. In our ancestors' days, men and women worked together on the Chilkat blanket (the predecessor of button blankets), the women executing the men's design with great

skill. The same applies for the execution of button blankets today. We complement each other's skills.

Every blanket is a different challenge, and I like that. The material is another challenge. Today we have higher-quality materials available to us. This gives us advantage over our grandmothers and great-grandmothers. They did the best with what they had, utilizing anything that they could get their hands on. They valued every piece of cloth they received: one can tell this by some old blankets in museums, where design work was pieced together with pieces of wool. Nothing was wasted.

Our grandmothers who created these pieces were honoured in our culture as clever, gifted ones. Their works speak to us now of their inner strength, discipline, and the need for ceremony, as they carried on their handiwork from generation to generation. They were recognized as important providers for family and ceremony. Chilkat blankets were woven by special, accomplished weavers and worn only by high-status people and shamans. Spruce-root hats with woven rings on top were like legal documents, representing potlatches the wearers had given, thereby gaining the right to wear them. These handmade valuables were ways of recording our history. The button blanket is now part of our way of recording history. By the example our elders have shown us—that appearances are very important in ceremony and self-respect a common value—the way we carry ourselves in public, appearing in a button blanket with our family crest, shows pride in where we come from. There is a particular dance we do now which we learned from the old people: it is a song about showing off your blanket. We dance in such a manner where we twirl our bodies around to the beat of the song, our blankets flaring, showing our backs with our crest to the audience. To our people, it was not in a boastful manner, but an established, recognized pride of kinship.

I would like to reflect back on my childhood, and how my grandmother had an effect on me. I was only thirteen when she passed away. She was a religious person, always going to church and serving the church all the time that I remember her. She never talked about the old Haida ways. This was during a time where those things were not considered of value. But before she died, she did an amazing thing. She gathered her five daughters together and had one of them write down and record on tape all our Haida names. She had seventy-two grandchildren then. It was very important to her to name all of us. She remembered all these names from where she came from, Howkan, one of the original Alaska Haida villages. She told us:

"Names are carried on through families. Two or three big families fight over a name, so it wouldn't die in the family. That's the way it be a long time ago. We still believe in that, to carry the family's name. We won't forget our family way back generations."

She knew she held the knowledge of where we come from and how important that is to keep alive. She didn't talk much about the culture, and suddenly she wanted to talk about it in a manner which was very strong. This has made a lasting impression on me. She had a button blanket that was not used ceremonially, but stored away. I remember that our crest was on this blanket. It was a two-finned Killerwhale, which is our main crest. She told us our history, that we come from the *Yak'laanas* clan. It is a Raven clan, the largest surviving clan among the Haida. We come from the Brown Bear House. Our other crests are the Dogfish and Berry Picker in the Moon. Nonnie Florence Davidson is from the same clan I am from. When I asked her, "Why do we have these certain crests, and not others?" she told me, "So the next generation can trace where they come from and who they belong to: otherwise, they would not know who their fam-

ily is in the future. Families were always close together in the olden days, they lived in one house. That's why you say you are from the 'Brown Bear House.' "

"And how did they get these crests?" I asked her. "The families would all work together on *watleth* [potlatch]. When they had gathered enough things for it, they invited all the opposite clan to the *watleth*. Sometimes feasting would go on for ten days and nights. They gave away piles upon piles of wool blankets, to everyone from the opposite side, enough to make one button blanket. They would potlatch for their children when they tattooed them. My mother had them all over her legs, and my father all over his body. They used to think low of you if you had no tattoos. When the missionaries came, they put a stop to the tattooing, so my father made silver bracelets instead."

I became more curious about the origin of button blankets. At every opportunity, I questioned the elders. One very scholarly elder from Ketchikan, Alaska, Robert Cogo, said:

"In 1790, the fur traders came from California with big abalone shell. The Haida took it in trade for sea-otter furs. They were highly prized, and the artists took and made buttons and ornaments. Later on, they brought in wool blankets and pearl shell buttons. In 1825, the Hudson's Bay Company set up a store in Masset. Wool blankets was the main commodity, and much potlatching took place at this time. Around 1880, the missionaries were sent in to 'civilize' the Haida. The high-ranking and the shamans were the hardest to control, so they made them deacons and elders in the church."

All Northwest Coast native peoples have gone through similar assimilation and change. Our elders were constantly giving us the message to adapt to the white man's ways, to speak their

language, learn their laws and religion, etc. It is a recent change where they are opening up old knowledge to us, and as the succeeding generation they have offered us this new cloak to wear. It is the button blanket. With about a hundred and sixty years of history, it has survived the changes. To me, it is the symbol of that change. In applying the European materials to the belief and practice of visually recording lineage, they have left this to us as a reminder that change is inevitable, but that songs, dances, and ceremony should always remain the centre of that change. I see button blankets as a symbol of progressive tradition, identity and rituals. It is innovation.

We are witnessing a new change now. Where once the songs and dances were pushed under the rug, we, the elders of the future, are lifting that rug by once again instigating potlatches, songs, and dances based upon our traditional roots, and by the inspiration to keep tradition moving, creating new songs, dances, and rituals. Where once the button blankets were sitting in closets, they are now on the people at potlatches, feasts, weddings, graduations, and totem pole raisings. In most Haida homes there is a button blanket, and songs are becoming more familiar to the younger children. Children in the village of Masset are proud to be a part of Claude Davidson's dance group. They show up every Monday night to practise eagerly. Recently, I was in Skidegate for a big feast. Everyone was making their way to the hall with their button blankets on. Three little Haida girls were showing each other how they move their feet when they dance. It really moved me to see this. I am thankful to be a witness and a participant of this positive change. The Haida have come full circle.

Button blankets started to be worn by the Haida during the time of the sea-otter and fur-seal trade with European and American sailing ships. Originally, clothing was made of fur, bark, and tanned skins. The chiefs also wore the Chilkat robe, woven from mountain-goat wool and yellow cedar bark.

The Haida traded with other tribes for things they did not manufacture themselves. With the Tlingit Indians from Alaska, they traded canoes for Chilkat blankets and copper. From others they got the hides, shells, food, and oolachen grease. The first items they wanted from white traders were iron blades to make their wood carving easier. Later, they wanted cloth blankets and buttons.

"On woman's dress, the early costumes ... were ornamented elaborately. The dresses were tightly fitted stays of cloth, often scarlet colour ornamented with pearl buttons. European blankets across their shoulders made up the costumes of the Indian women" (Niblack 1890:266).

On ceremonial occasions the chiefs and their families dressed in the finest garments, complete with carved rattles and headgear. The family would work for several years to make the finest regalia to be worn or given away at a potlatch. At one time, furs were used as currency, but after the fur trade, Hudson's Bay blankets became a form of money.

After 1880, missionary influence and the law discouraged the Haida from using their traditional garments, and many were sold to museums. After 1950, some people started making button blankets again. By 1970 many people had them, and this led to the revival of the dances and some of the ceremonies, but it can never have the same meaning as it did originally, because so much has been forgotten.

Kwagiutl ceremonial blankets

Daisy Sewid Smith (copyright 1985)

The button blanket did not come into existence until after the Fort was built at Beaver Harbour [Port Hardy, British Columbia] in 1849. Prior to this, the Kwagiutl people used fur or cedar bark blankets. The type of blanket used depended on the rank of the individual. The ranks and types of blankets used were as follows:

— chiefs, chieftainesses used grizzly-bear blankets;
— princes, princesses used grizzly-bear blankets;
— aristocrats of lower rank wore mountain-goat, marmot, deerskin and sea-otter blankets;
— commoners used cedar bark blankets decorated on the edges with fur.

As the Hudson's Bay Company demanded more of their furs, the Kwagiutl people started making ceremonial robes out of yellow cedar with a narrow fur border around the blanket. Chiefs, chieftainesses, princes, and princesses added a border of grizzly-bear fur around the border to show their rank.

When a princess was being married, her blanket was covered with abalone shells, and during the wedding ceremony she would take the blanket off and put it on her husband.

The Hudson's Bay Company wanted to discourage the Kwagiutl from keeping precious furs for their own use, so they started making what was known as the "Hudson's Bay blanket." They traded these blankets for Kwagiutl fur.

The Kwagiutl designed these blankets for ceremonial use by sewing on strands of cedar bark and abalone shells. They referred to their new blankets as *gyen'guk'to'la* (a place where you sew things on). The button blanket came into existence when the Kwagiutl saw a man wearing a buttoned suit. These men, we later learned, were called "Cockney Pearlies" from England. They covered their clothing with thousands of pearl shell buttons that they had cut out from cockle-shells.

The Kwagiutl designed their new blankets with a red border to represent their sacred red cedar bark. They put a family crest or tree of life on the centre of the blanket and other tribal symbols around the border. They outlined these designs with pearl shell buttons [from China] sold at the trading store. The Kwagiutl called these buttons *q'qa'gwe'tsum* (mother-of-pearl). They added their abalone shells around the edges and adopted some of the designs of the Cockney Pearlies to add more elaborate design to their own. Chiefs, chieftainesses, princes, and princesses wore a button blanket called *kis'ga'ma'la* (having many buttons). Those of lower rank wore the *nem'dzux'sis'ta'la* (having only one row of buttons around the border).

The blanket on display is a replica of a blanket owned by our grandfather, James Roberts. The original blanket is over one hundred years old and is now owned by my sister, Dora Sewid Cook, one of the artists who made this blanket. The design on the blanket centre is the tree of life or red cedar, appropriately so called because the Kwagiutl people depended on the red cedar for all their needs. The tips of the branches of the tree of life are decorated with a design adopted from the Cockney Pearlies. On the edges are designs representing mountains. The legends of the Kwagiutl tribes state that they encountered a supernatural bird on top of a mountain after the flood. On the front edge is the design of an arrow representing the wars that they had in the past.

The copper design is put on the centre of some blankets, but could only be worn by certain

individuals. The man received a copper as dowry and the bride who gave it to him are those who could wear this design. Their children could wear it around the border of their blanket.

The ranking system of the blankets has disappeared and is no longer practised by the Kwagiutl tribes. Everyone now wears button blankets indiscriminately. In earlier times, only the aristocrats attended the ceremonies because you had to have a position to attend. Now, everyone attends the potlatch. The Kwagiutl no longer use Hudson's Bay blankets or pearl shell buttons as these are no longer available, but the Kwagiutl people have adopted other materials and their blankets become more colourful and elaborate as the years go by.

Button blankets on the west coast?
Ron Hamilton

Throughout all time, Westcoast people have been aware that one's external trappings and appearance are on some occasions most important.

During myth time, *Kwatyaat*, our original super-hero, donned one of his many robes of power and became a great baleen whale. Before that story ends, he has drowned three great Thunderbirds, leaving only one bird in that nest to hunt whales, in competition with the *Hikuulthath*.[1]

Another ancient Westcoast story tells of a group of little boys who had the power to transform themselves into small white dogs, merely by donning special robes. After their mother burns their robes of power, they mature quickly and become great whalers. Finally, they leave the west coast and take up residence at Cape Flattery. The story was meant to account for the superiority of *Tlaa-asath* whalers in pre-contact times.[2]

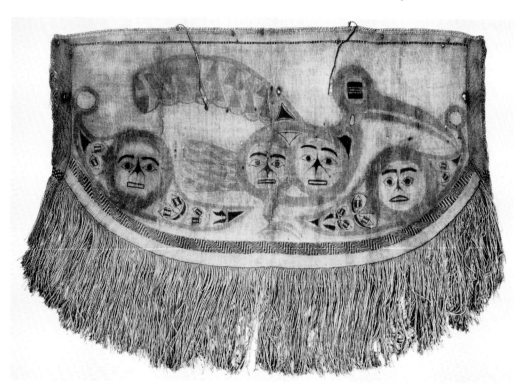

Figure 36.

When Captain James Cook made his historic visit to Yuukwaat in 1778, John Webber, an artist with that expedition, did several sketches of powerful Westcoast chiefs in sea-otter robes—robes of power. When he left Yuukwaat, Cook took a number of the sea-otter robes with him. Later, they were sold in Canton at exceptional prices.[3]

That expedition later returned to England with a number of woven cedar bark cloaks. Some of these were decorated with designs woven in contasting colours. At least one of them had an elaborate painted design depicting a bird and four highly stylized human faces (figure 36). The fine weave, the beautiful long fringe, and the red and black painted design, skilfully executed, assure us that, worn by the right individual, this truly was a robe of power.[4]

John Webber's famous sketch of the interior of a house at Yuukwaat cost him every brass button on his uniform.[5] Later, during the maritime fur-trade era, blankets of various sorts and pearl buttons were traded on the coast. But when and where pearl buttons and trade blankets first came together in the form of a "*button blanket*" on the West Coast is not known.

Our oral history does not account for their origin or arrival along our coast. There is archaeological evidence from a site in Barkley Sound indicating that pearl buttons were used to decorate dance robes (figure 37) in that area as early as 1820, plus or minus twenty years.[6] A photograph by S.E. Leach of a tree burial near the present town of Ucluelet (figure 38) may be further evidence of an early date of introduction.[7]

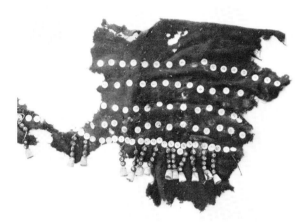

Figure 37.

Figure 38.

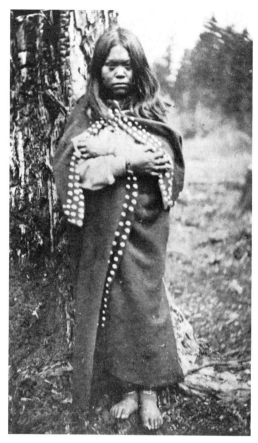

Figure 39.

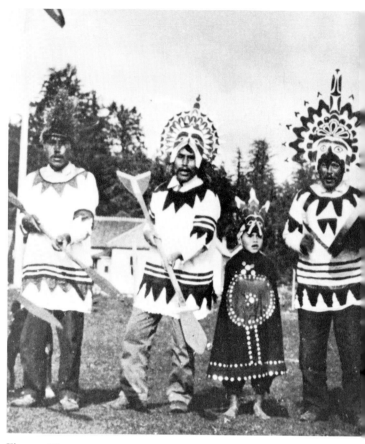

Figure 40.

The earliest historical photograph I've found of a Westcoast person actually wearing a button blanket is the one of *Tu-te-ma*, a *Tsishaa-ath* girl (figure 39). The picture was made by Charles Gentile, a photographer who travelled in Barkley Sound from 1862 to 1866.

The heavy wool blanket, decorated with a wide, dark stripe reminiscent of the Hudson's Bay trade blanket, reaches down to the young girl's ankles. The borders of the robe have, in different sections, two or three rows of medium-sized buttons for decoration. The buttons look as if they might have been retouched in developing the photograph: however, movement during exposure may have caused the fuzziness of their bright reflective surfaces. The girl is wearing what appears to be copper wire anklets, a fashion dating from the earliest European contact.[8]

In 1884, due to pressure from church groups and a few Indian agents, the potlatch was banned. Along the west coast, people carried on much the same as they always had. Few people feared prosecution for potlatching, as their villages were for the most part remote. Also, Westcoast potlatching never stressed the competitive destruction of property so repugnant to early settlers, and thus was spared their wrath. In 1915, halfway through the period of the potlatch ban,[9] Augustus Cox visited the *Heshkwii-aa-ath* at their main village and photographed large groups of costumed dancers. One of his pictures (figure 40) shows Hypolite Ignace wearing a bird's-head frontlet and a button blanket. The robe is worn "backwards," exposing much of its design field. The design is very abstract: a large circular appliqué of contrasting coloured cloth is decorated with rows of small buttons and connected

to the border of the blanket by a swatch of material. This connecting strip and the borders have two rows of small buttons for decoration.

In 1928, Governor-General Lord Willingdon visited the *Muu-achath* at Yuukwaat, the site of Captain Cook's historic visit. He was welcomed and feted according to Westcoast traditions of hospitality. Captain Jack, a local chief, gifted Willingdon with a forty-foot heraldic pole. A photograph (figure 41), possibly taken by A.E. Lord, the owner of the nearby Nootka Cannery, shows Captain Jack and Napoleon Maquinna, the head chief of the *Muu-achath*, standing on either side of the pole.[10] Both men are wearing blankets with rows of tiny buttons, creating a glittering line parallel to their blankets' outside edge.

During any particular historical period on the west coast, a number of styles of ceremonial robes were in use. In 1778, both sea-otter robes and cedar-bark textile robes were worn. Some of the textile robes had decorative zigzag stripes worked into them: at least one was painted. In 1915, Westcoast individuals also wore various robes of power, according to the occasion and their personal preference.

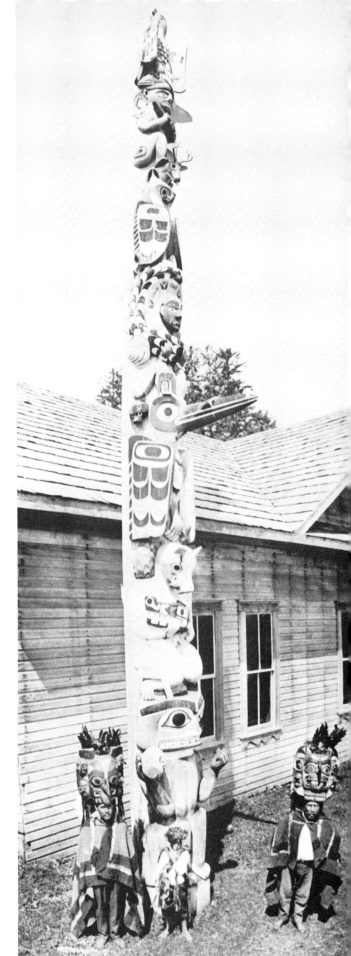

Figure 41.

Figure 42.

A second photo from agent Cox's album (figure 42, c. 1915) has six *Heskwii-aa-ath* in various costumes. One wears a dark-coloured apron, having buttons sewn on it in geometric patterns. A second man wears an apron with tin bugles, perhaps replacing deer-hoof rattlers of an older form.

A third man has on a muslin shirt with a painted design representing an owl. Wrapped about him is a painted muslin shawl with long fringes, a spectacular robe of power. A masked dancer is wearing a loose-fitting, two-colour tunic with many eagle tailfeathers attached, a very powerful robe of power. The lady at the far right of the happy group is wearing a Pendleton Indian shawl from Pendleton, Oregon—the latest style!

Over the last 208 years, Westcoast people have worn a variety of ceremonial robes. We have used sea-otter robes, woven yellow cedar-bark fringed robes, trade blankets—some with appliquéd designs and pearl-button decoration—painted muslin shawls, Pendleton shawls, and garish satin shawls with sequin designs, the brighter the better. Through all these changes in style, the intentions of their owners have been

the same: to be obvious in public, to catch people's eyes, and to project nobility, wealth, and power.

Today, Westcoast people still wear woven robes with fringed borders and painted designs representing animals. Unlike robes collected by Cook 208 years ago this month, our present robes of power are not yellow cedar bark and they do not take six months or a year to manufacture, but they are still robes of power.

[1] Northwest Coast Indian Artists Guild 1977; #7, *Kwatyaht's Gift to Teetkin* by Ron Hamilton.

[2] Nootka Texts, 1939, p. 55: "The Dog Children" by Edward Sapir.

[3] The Journals of Captain James Cook on His Voyages of Discovery. Beaglehole edition, 1967.

[4] J.C.H. King, Artificial Curiosities From the Northwest Coast of America, 1981, p. 83.

[5] The Journals of Captain James Cook, p. 320.

[6] Linda Roberts, "A report on a Burial Recovered From Dfsi 1, Howell Island, Barkley Sound, 1973." (Also, personal communication with Richard Inglis.)

[7] "The custom of tree burial was abandoned in Barkley Sound about the turn of the last century. However, in Alberni Valley that practice was carried on at least until 1910, when I was a boy. The tradition of tree burials was quit long before that of cave burials." Dr. George Clutesi, October 1985 (personal communication).

[8] The photograph appearing on the front page of the 18 March 1975 issue of the *Ha-Shilth-sa* was not taken in Barkley Sound, but rather at Cape Caution, on the east coast of Vancouver Island.

[9] The potlatch was banned in 1884. In 1951, the Indian Agent Act was revised, making it once again lawful to potlatch.

[10] The masks in this photograph are now at the UBC Museum of Anthropology. The pole is still standing at Yuukwaat. Benedict Jack is the young *haa'matsa* shown.

Button-blanket designing, Gitksan style

Vernon Stephens, Kitanmax School of North-west Coast Indian Art

Button blankets depict and display family crests, often within the design area shown in the diagram. This design arrangement brings recognizable elements to the front of the blanket when it is being worn, thereby giving a good "view" either front or back. The traditional Gitksan blanket has no design on the borders.

Button blankets, because of the instability of the base material and appliqué, should have a very simple design. If this is made clear to the person requesting a button blanket, designing will be much easier.

Steps in button-blanket designing are:

1. A request from a purchaser (or an irresistible desire to make one);
2. The measurements of the wearer;
3. Crests to be incorporated (in this case, the Question Mark);
4. Any special ideas the client may wish to incorporate;
5. Rough sketches to show the client;
6. Materials (manila tag or heavy poster paper, large- and small-point felt pens, cloth) assembled.

Tape the paper and cut it to the exact size of the proposed blanket. On most northern-style blankets, a four-inch border of the appliqué colour is allowed for on the top and along both sides, but not at the bottom. The border usually breaks at the back of the neck, and a lighter-weight, more pliable material is inserted (figure 43).

Figure 43.

Once the border is established, the main design area is set by centering vertically and horizontally off-centering closer to the top, so as to display the design to its fullest advantage while being worn.

Having positioned the design space, begin the rough sketching to establish where the main and permanent lines are going to be. Stand back and view from the top and bottom. Decide if your lines are positioned properly. Adjust until satisfied. Darken the lines and then stand back for another look. This is necessary to achieve your goal. Now check all areas that connect, making quite sure that **they are well defined.**

Figure 44.

Having satisfied yourself that this is the design you wanted and that it meets all your hypercritical standards, define the background and design areas using the wide and fine felt pens. Defining with felt pens is necessary, as the person who cuts and sews may not be too familiar with the design's requirements. After this is done, you can proceed with bridging (figure 45). These bridges support the design elements after the appliqué is cut, and minimize possible distortion by the sewer.

69

Figure 45.

Having established bridging and cut-out areas, attach the design to the appliqué material using sharp pins (preferably with large heads), and ensure that the design is properly centred and secured thoroughly (figure 46). Begin cutting out the background areas between bridging.

Figure 46.

After cutting carefully, move the design and the attached design material to the background blanket material, leaving the paper pattern on top. Again, centre carefully and pin to the blanket in the same manner as before, taking great pains to maintain the lines of the original design. Do not discard the paper from which you cut the pattern. When the appliqué is sewn on correctly, the cut-out area should fit precisely over the sewn appliqué design.

Small buttons should be used to outline the design: large ones will not meet the demands of the art form. An interesting effect can be achieved by using thread of the background colour when attaching the buttons. This also looks better from

the wrong side of the blanket. In traditional blankets, the buttons along the borders break at the back of the neck and do not follow the front border to its base, but usually "run out" four or five inches above the base. Large buttons are satisfactory along the borders (figure 47).

Figure 47.

Dancers do not like the duffle blankets because they are too heavy and warm, but from the point of view of the artist, the deep pile of the blanket cloth and its sheen do the most to set off the appliqué and the brilliance of the buttons.

Gitksan ceremonial robes

The Book Builders of 'Ksan[1]

"Only he who walks
in the clearness of the sky
may wear."[2]

Eighteen old, properly validated ceremonial button robes, *gwiis gan m'ala*, reside at 'Ksan. Nearly one hundred of their contemporary relatives are also in residence. This paper deals only with the older members of the family.

None of the older robes is younger than sixty-five, and some are over one hundred years old. All are dark navy or black shoulder-to-ankle coverings or wraps of blanket cloth, highlighted by scarlet appliqué and enlivened by the rainbow lights from hundreds of white mother-of-pearl buttons.

The traditional ceremonial button robe is one of the most important documents entrusted to the care of a Gitksan who "wears" a chief's name or title. The blanket, along with the chief's headdress *(amhalayt)*, the rattle, and the totem pole, testifies to age-old prerogatives and obligations. Only on occasions of exceptional importance was, and is, the *gwiis gan m'ala* worn or displayed. In the last thirty years, most ceremonial robes stored in 'Ksan's Treasure Rooms for safekeeping have been taken out by the owner family only when one wearer of the name crossed the shores of the sky and a new wearer was being invested or chosen.

The term, "button blanket" is a poor translation for *gwiis gan m'ala*, which literally means "covering or robe with buttons." "Ceremonial robe," "chief's robe," or "chief's button robe" are preferable. "Blanket" implies bedding.

Before beginning this paper, a group of Book Builders spent two days renewing acquaintance with the robes and enjoyed every minute of it. Those visionaries who created the crests or symbols believed wholeheartedly in the events depicted. One **knows** the strength of Giant Devilfish, of Rainbow Man, of Living Smoke Hole. The headless Wild Crabapple Tree sees, hears, thinks, and could act. The blankets fairly shout their visual messages: power, authority, order! A bonus was the charm of the tiny, lacy buttons, patterned in amazing variety.

Artistically, the robes are not of equal merit. As communicators, all do a fine job. More than half the appliqué figures are quite realistic, while others are "penned in the only script known to the grandfathers,"[3] the "eye art"[4] of the Indian peoples of the Pacific Northwest Coast. Robes from villages closer to the coast are more stylized; in fact, some historians in the Hazelton-Kispiox area disapprove of the "eye art," claiming that the figures aren't "properly standing" (standing naturally, realistically). The designs tend to fill the available space. With one exception, vertical bilateral symmetry is uniform. Where the design area is not filled, massing always occurs toward the top and centre.

Many robes show remnants of various now-unknown appendages or decorations, particularly those robes with more realistic designs. One of these is animated by several small faces, out of whose mouths tiny tongues protrude as the wearer walks. Similar enlivening additions may have been attached in other cases.

The sewing is uniformly careful: all but one are hand-sewn. This exception apparently was made for repairs only. The machinist set herself the enormously difficult task of fastening down the frayed edges by stitching a strand of two-ply yarn along the perimeters of the centre symbols. Not a stitch is out of line.

With stroud, duffle, buttons, sinew, and thread, bygone artists created graphics of high calibre. It

is sad that the stories the graphics cue cannot be told here, but 'Ksan repeats no family histories.

Three types of robes are housed in the Treasure Rooms: the crest type, the all-tribes type,[5] and an adaptation of the panel type. A fourth type, the plain blanket, is known to have existed, but local informants are unsure of its usage. This blanket is the same as the crest type, but without crests, and may be the type of button blanket recorded as having been given away in quantities at potlatches on the coast. Recipients could then add appropriate crests at their leisure. Another possibility is that the plain type was worn by low-ranking nobility on the way up the ladder—those of noble birth, but without ranking names.

Visually, the crest type is the most spectacular and the one that comes to mind when button blankets are mentioned. Crests, say local authorities, are "markers" or "flash cards" for historical events which occurred to specific maternal ancestors at specific times and places. No ancient robe in 'Ksan's care depicts an unidentified Frog, Thunderbird, Eagle, or whatever. To validate a crest, a Gitksan must have a clearcut experience or adventure to relate. For example, an unusual Marten, which came into the hands of an ancestor during a highly successful retaliatory raid, could be (and was) validated and perpetuated. That specific Marten, as witnessed by the astounding success of the venture, was obviously the personification of *Nax Nok* (A Power Beyond the Human). Without *Nax Nok*'s support, no human could achieve success in the view of the grandfathers.[6] Spectacular success proved spectacular cosmic support: power.

In general, several insignia are included on each crest-type robe: a chiefly line has a long history of successes. The documentation for each crest is known and recited at feasts where those attending verify its import, its prerogatives and obligations.

The all-tribes type's resemblance to ecclesiastical robes is mentioned by most people who look at them. Of the four Tahltan types at 'Ksan, no two are identical, though at first glance they are the same. On all four, for some reason or other, the top centre panel, or parts of it, stands out from the main blanket. Perhaps this is a descendant of the hood on a cowl or collar on a midshipman's Sunday "middy"? The two lower strips of red also form a long vertical "flap."

All 'Ksan's Tahltans appear to belong to families known to have migrated from the north. One knowledgeable consultant claims that "button blankets came from the Russians." The accession file notes, "Only the wisest men wear them." Alaskan researchers have identified the Tahltan as the most prestigious style (Otness 1979: 77), where deLaguna puts the crest type at the top of the list.[7]

One of the four Tahltan blankets belongs to the head chief of Gitanmaax. It is possible that the village leader, to show impartiality, did not display the "marker" of any House. The term "all-tribes" likewise may indicate village leadership. The four Tahltan robes average many more buttons per blanket than do the crest-type examples at 'Ksan.

On three of the four Tahltans, solid red borders with one or two parallel rows of white buttons extend along both sides and right across the top, whereas the crest type's red borders vanish at the neck area and are replaced with thinner material of a different colour. Tahltan front borders run right to the bottom of the robe: crest-type borders tend to stop short of the hemline, and the button accompaniment is even shorter. No 'Ksan-stored robe has a bottom border. No bottom border of any colour, ever.

The only panel-type robe in 'Ksan's keeping looks like a Tahltan type, but stationary appliquéd panels take the place of the "unfastened pieces" of the Tahltan.

Figure 48. All tribes or Tahltan type robe.

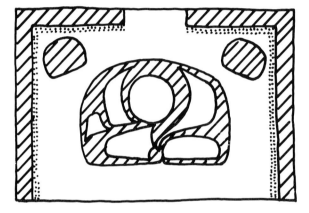

Figure 49. Crest type robe.

The typical panel type is like the robe just described, but the lower two thirds of the area between its borders is divided vertically into three sections by two red strips which extend to the bottom of the garment. Borders and strips are approximately four inches wide. All are edged on one side with one or two rows of small pearl buttons, usually white or near-white. The size of buttons may vary a little. When more than one size is used, the rule appears to be what you do on the right, duplicate on the left. This rule holds for all types.

The visit with the button-blanket collection pointed up missing links in information about the robes. Why was there no red border at the bottom? Why was there a "neck break" on the crest type and none on the Tahltan? Why was the rectangular shape used when a rounded base like that of the Chilkat robe was better for dancing? Why did the colour navy predominate over black? What was the significance of the buttons? What was the implication of all the colours? After the Book Builders reviewed the 'Ksan files and asked advice from other historians, few hard and fast facts emerged, but what was learned is arranged below under suitable headings for clarity, and passed on largely without comment.

Why no borders or buttons along the bottom edges of robes?

The robe flows more easily and gracefully when the wearer dances. 'Ksan learned the hard way about the discomfort of a blanket with a quantity of buttons on the hemline. The rows of buttons whip the dancer's legs and tend to latch on to each other and immobilize the robe's sway.

In the nineteenth century, all blankets were worn with the pile downward so that the rain would run off (Hansen, 8). The early dyes were not colour-fast, so a navy blanket's bright red border would soon turn dirty purple in the rain. In 'Ksan's Treasure Room, there are two very old blankets from which several inches of the front borders have been removed at the base, as evidenced by remnants of stitches and cloth. There are also stains from seepage of dye a little higher on one border.

Colours

The colours used on the *gwiis gan m'ala* are those common to Northwest Coast Indian art except that the light blue is missing, unless the abalone shell is attached. The 'Ksan files have many references to colour. Though none was recorded with specific reference to the blankets, any could be applicable.

— "Black is char that fire cannot eat."
— "When you take baby out at night, put little bit black on the nose. It keep *lulak* (ghosts) back."
— "Black smoke rise from fire that old people build to send message to *Lax Ha*."[8]

- "White means peace. The soft white feathers (down) of the strong bird."
- White may have indicated purity. During the final feast of the old-style potlatch, unmarried but marriageable girls of the host family dressed in white caribou-hide shifts and stood motionless and unsmiling during the robing of the chief and the final distribution of property.
- One word for "red" in the Gitksan language has the same root word as "blood."
- Several histories mention blood as a shield, a kind of armour. One such history tells how an ancestress saved her brother from the destroying, knife-like snout of a monster by painting the brother with menstrual blood.
- "At the boundary between one chief's territory and another's, a tree was adzed off flat on both sides for about five feet, then coloured red with blood." This was a warning to trespassers from either side. Do the robe's red borders signal the same message?
- *Mas* (red paint powder) is greatly valued by the *halayts* in their work. The red represents blood, and the blood represents life" (Sophia Mowatt).

The House theory

According to one line of thinking, the *gwiis gan m'ala* represents a house. The red borders are the wooden frame and roof on all types. The break at the neck is the smoke hole in the crest-type robe: in the Tahltan style, the separate, "unfastened panel" represents the smoke hole with its wooden covering. There are no bottom borders because the old houses did not have wooden floors. The crests on the blanket parallel the crests on the house front. The chief who heads the House, the chief who "wears" the name to which the house and crests belong, is both protector and protected.

Why the "neck break?"

"The material wears out at the neck and had to be replaced." Others suggest that the wear would be equally bad on the Tahltan type, which has no break. The supporters of the house theory consider the "break" to be one of their most telling arguments, particularly as the Tahltan top centre panel provides a smoke hole without requiring a "break" at the neck.
- "The blanket sits better, fits the shoulder better, if the wide, thick stroud is replaced with thinner material at the neck."
- "The stroud clings, and might interfere with the movement of the *amhalayt's* (headdress's) train during a *sim halayt*, an honouring or peace-insuring 'dance' performed only by chiefs."

Buttons and Other Ornamentation

Though no robe at 'Ksan is now trimmed with shell, white shells adorn several aged aprons. It is believed that crests were delineated originally with dentalium, white shells formerly used as currency which were the forerunners of the white pearl buttons. 'Ksan's needlewomen who have worked with dentalium shell know what a laborious chore it is. Each shell has to be soaked, cleaned, and pierced. The right size must be selected and carefully attached, so that the artist's model is followed to a T.
- "Good mother-of-pearl buttons are a thousand times easier to use, and besides, they shine so nice."
- Abalone shell was probably hung on the blankets. "When I was a kid, there'd be lots of pieces of abalone shell, with holes pierced through, in the village." Though no robe in the Treasure Rooms retains abalone shell, strong threads of sinew, linen, or cotton hang from every *gwiis gan m'ala*.

Words from Historians

"Nowadays, just anyone can sew a blanket. Long time ago, only the chief's dad's people could make the design or sew it, probably his father's sister or brother. Anyway, someone on his dad's mother's side."
- Button robes must be stored with the buttons and designs folded to the inside.
- "It's important to remember that a chief is

accountable to his *wilp* (House) for the regalia and things in his keeping. He doesn't own them. He must take good care of them."

— There's some evidence that only three chiefs in a House were entitled to wear button robes: the main chief and the chiefs to his immediate right and left, when seated ceremonially.

— It may be that for each House, there is a common crest that is displayed on all button robes of that House. This is placed on the centre of the blanket. A given chief's own crests, those that belong to his name only, will be on either side or elsewhere on the robe. At the present time, the Book Builders have not been able to document this statement fully.

— Chiefs may loan blankets to others in the same House or even the same *pdeekt* (phratry), but the loan must be announced publicly.

— "When you look at a chief wearing a button blanket, you know that all the family's wisdom and knowledge has been passed on to him. He can make important decisions because of this."

— "It's important to remember the things a chief has to do. He doesn't just get, he has to give. He has obligations, lots."

The Right Time and Place to Wear a Ceremonial Robe

When "ceremonial robes" are the topic, both the Chilkat robe and the button robe should be taken into account. Do the Gitksan consider one to be more prestigious than the other? Are they stand-ins for each other?

The language supplies no definite answers, nor do memories. The general opinion is that at one time the Chilkat robe "stood higher," and might have come into prominence along with the so-called "secret societies."

Everyone is agreed on one aspect: neither the ceremonial button robe nor the Chilkat robe is worn during *halayt dim swanasxw*, the medicine man's curing activities: not by anyone, in any circumstance.

All agree that neither robe should be called a "dancing blanket." Both may be worn during "dances" such as the *sim halayt*, where the objective is the distribution of the powerful eagle down, symbol of peace.

The ceremonial button robe is designed for temporal, not spiritual occasions. The crests proclaim the rank, the social status of the wearer. That status was and is reinforced by the button robe's acclamation of cosmic support—power—the history of which has been validated properly and perpetuated through time.

There is considerable disagreement about the type of occasion where a ceremonial robe is appropriate today. Recently, robes have been worn to gatherings of economic and social importance to the Gitksan. At least one button robe has been ratified in church, where the assistants were selected according to Gitksan tradition. Usage outside the traditional ceremonies does not meet with the approval of all, but appears to be on the increase.

Robes of Power

'Ksan's files hold many references to "power." Defining the word is rather like defining religion, or love, or other concepts for which each individual has a personal definition. The pre-contact Gitksan knew that a human being was just a shell, and that whatever abilities a person demonstrated came from *beyond*, from *powers*. Each figure, each crest on a robe, is a visual cue which triggers the viewers' memories, reminding them of the whole wondrous happening and its continuing significance, its *power*.

The Gitksan who legally wears a traditional ceremonial button robe has demonstrated, beyond the shadow of doubt, his capacity to provide for the people, look after the people. This capacity will have been proven publicly at a *yukw*.[9] There, the histories of the crests will have been recited, the rights and prerogatives expressed, the guest witnesses excellently entertained, lavishly feasted, and generously compensated for

ratifying the statement of these rights and pre-rogatives—including the robe and its crests, its visible symbols of power.

In times gone by, the community knew that a person who could amass sufficient reserves—human, material, and spiritual—to "feed all the people," could do so only because the Power Beyond the Human, or *Nax Nok*, assisted him. Only then could a chief achieve power. Today, the more spiritual believe, as did their ancestors, that success stems from sources other than an individual's own power.

[1] The Book Builders of 'Ksan work by consensus, rewriting until all approve the content.
[2] Jeffery Johnson, 1958.
[3] Bill Blackwater, UBC totem pole raising.
[4] One of the names for Northwest Coast Indian art.
[5] Also known as the Tahltan/cloak/cape and *Gwiis xwsu-duuhl* (for the purpose of humpback).
[6] There is diversity in the use of *Nax Nok*: for some, *Lax Nok* is correct.
[7] See diagram.
[8] Literally: "the on top air," the beyond, the source of power.
[9] The most significant event in the Gitksan social, economic, and spiritual worlds.

The significance of colour among the Kwagiutl [1]
Martine J. Reid

Among the Kwagiutl, in the ritual context, the spectrum is dominated by the black colour, the red, and the white. To be an accomplished human being, one has to attain all three predominant colours of the button robe. This and other uses of colour, both sacred and profane, are examined below.

Black
When painted on warriors' faces, for example, black connotes not simply violence and aggression, but also protection against any danger of death, more specifically against danger of a supernatural or ritual nature. The use of the colour black was thought to make the wearer invulnerable. Not only the warrior but also the *hamatsa* initiate uses black as protection. Black is mostly a masculine colour, but not exclusively.

Red
Red is the colour that expresses the excellence to be found in the realm of the supernatural. *Tsetseka (tseka* means red), which has been interpreted as the "winter ceremonial," really means the Red Cedar-bark ceremony (the *hamatsa* ritual). Since red is the colour of the supernatural in the Kwagiutl world view, it also connotes wealth, supernatural power, life (human or animal), and nobility. It seems to me, because of all the connotations, that red is a stronger colour than black. In the context of myth, to reach the house with the red smoke they had first to pass by the house of the white smoke with the Goat. Then they had to kill the Bear and pass the house of the black smoke, and, finally, they reached the house of the red smoke. I see some kind of progression from white to black to red. In other words, the initiate has to overcome some kind of "black death" by overpowering the Bear to reach the house of the red, supernatural power and colour. It's only after having tested his strength and power by killing the Black Bear that the initiate has access to the supernatural power of

the red smoke. It's only after this that the initiate comes to wear the red cedar bark ring.

Outside the ritual context, red has something to do with life, whether human, animal or other. It also means power and is implicitly a symbol of rank as well as status. It is a masculine as well as a feminine colour because men and women have access to this colour.

White

White is the colour of serenity, peace, harmony, and spirituality. Pursuing something white (a mountain goat, a white sea otter, etc.) will lead to a series of sometimes dangerous events but also success in acquiring new wealth, new privileges. This pursuit can actually be seen as a metaphor for marriage alliances, the culmination of which among aristocrats is the transfer of privileges called the dowry. The white colour is the most difficult to explain in the Kwagiutl environment. Red and black are the dominant colours.

During their seclusion period, at the time of first menstruation, young women wore bands made of mountain-goat fur on their heads, wrists, and ankles. They would drink water out of a drinking tube made of bone from a bird. Shamans also used objects connoting white colour, such as bone.

In the public context, white means female maturity or womanhood and then white death. In the ritual context, I found that it means peace, as in the peace dance, and harmony. This is a feminine colour. White is also the colour of transformation. White is the most spiritual colour.

All three colours were worn by both sexes, but white is associated most specifically with the female aura as black is with the masculine. The red is sexually neutral.

In the myth of *Baxbakwalanuxsiwae* (Man Eater of the *hamatsa* myth), it is said that the white, black, and red smoke rose from the houses of the mountain goat, the black bear, and the man-eating spirit respectively. It is important to note that as the *hamatsa* initiation proceeds, the initiate dons items of regalia coloured according to this sequence: first, he receives the red cedar-bark neck ring, attesting that he "went through," as the Kwagiutl say, meaning that he went through the house that emitted bloody smoke, the house of the Great Supernatural One whom he conquered, acquiring treasures and new wealth. Then, as he becomes more tame and develops into a more cultural being, he receives a black-bear cape. Finally, when the taming and the initiation are complete, he is showered with white eagle down. It is only when the initiate "wears" the three colours at the same time that he attains the state of complete humanity.

[1] Based upon "La Cérémonie Hamatsa des Kwagul: Approche Structuraliste des Rapports Mythe-Rituel." PhD dissertation, Department of Anthropology, UBC, Vancouver, 1981.

Results

Simple, single answers are hard to come by in the real world. What's the most beautiful colour in a rainbow? What's the most tuneful note in a scale? What's **the** role of a ceremonial button robe?

The team's research indicates that the robe's role varies from area to area, village to village, House to House, and even from chief to chief in the same House. The traditionalist regards the blanket in one way: his innovative brother may have altogether different ideas. Diversity may be the state of the art. In thirty-five years, David Gunanoot, a Gitksan elder, found only one occasion worthy of his *gwiis gan m'ala*: the raising of a totem pole by the head chief of Gitanmaax. Agnes Cranmer asks her grandchildren which they want, the Eagle or the Thunderbird: they like the Thunderbird, so she makes Thunderbird-design robes for them (p. 49). Fanny Smith (p. 17) believes that "we have to put on quite a few feasts before we earn the right to wear a blanket." David Gladstone concurs with Fanny: "I have several blankets that I haven't shown because I haven't given a potlatch to validate them" (p. 42).

Others mention having worn ceremonial button robes at weddings, and the giving of them as gifts or honours. Albert Tait claims, "The blanket is not used for events such as a wedding." Yet were green blankets used at weddings, as Agnes Cranmer suggests (p. 49)? Carrie Weir, born in 1904, began making button robes in 1965, and recounts, "I make some to sell and most people like them for their walls."

All these people now respect the robe, as their interviews indicate, but their ways of showing that respect are as different as the red, the blue, and the white on the robes themselves. Respect for the robe, in some form or degree, does appear to be a common factor throughout the button-blanket-wearing world.

All the artists depict crests to which they are hereditarily entitled, or which have been given to them as honours or gifts, or which "belong to all our people," such as Dempsey Bob's and Ken Mowatt's Raven-myth illustrations. Or they invent crests, as is the case with Vernon Stephens's *Crab and Moon*. No self-respecting artist uses another person's or clan's insignia without permission from the owner.

The use of ceremonial button robes is increasing, though not always along traditional lines. Robes are frequently used as educational tools, or as the ambassador-type robe, or the honour-giving robe (Marion Hunt Doig, the many dance groups, David Gladstone, Florence Davidson).

There is "a remarkable uniformity of the arrangement of the button-blanket parts and decorations," as Bill Holm put it (1983: 61), "from northern Vancouver Island to the northern end of the Northwest Coast at Yakutat." There is strong family resemblance in the button-blanket tribe that can be seen at a glance, though the wearers may speak different languages and live a thousand miles apart.

For some ceremonial-robe makers, the robes were old family friends, neighbours who would be around if and when they were needed. "I never asked questions about button blankets. I have always felt that it was your mother's or your grandmother's duty to make button blankets. I felt that part of the art was going to be forever protected," Simon Dick asserts.

Among other sewers and designers, blankets were "VIPs" to whom they had an introduction in childhood and with whom they attended occasions. Agnes Cranmer, now in her seventies, received her first button robe when she was ten. Jimmy Sewid saw "hundreds and hundreds of them hanging in the big Indian houses" ready

for such occasions. For David Gunanoot, his *gwiis gan m'ala* lived in seclusion and appeared in public only for the "main part of a main thing." To Tony Hunt, the presence of the robe provided support and confidence: "I feel a spiritual strength."

For yet other creators of ceremonial button robes, those with understandable inhibitions and intellectual hangovers from the era of the potlatch ban,[1] the robe was better forgotten, a has-been with whom they felt uncomfortable, even insecure. Florence Davidson, ninety, hadn't witnessed the making of a ceremonial robe in her youth. When she did make one under tragic circumstances, to make herself "happy," she worked in secret over a two-year period. Robert, her grandson, describes his former qualms about wearing the robe.

When informally consulted, scholars and authorities inside and outside the Indian community freely admitted to having had a blind eye for the button robe. It appears that they were drawn to ancient and contemporary sculpture, argillite, engraved gold and silver, and prints, but the blanket cloth had little appeal, was not "really Indian," as one said. The truth escaped them: the materials are indeed non-Indian, but the artistry and original purposes are wholly Indian.

Some common factors of button blankets have been named, but unanswered questions remain, and some new ones joined the team's list. These must be written into the account.

Should button robes be used for solely educational purposes, inside or outside the Indian community? Thriving dance groups use button blankets extensively as costumes with no power. In fact, one dance group[2] had the opportunity to purchase a genuine piece of regalia, but the executive voted against its purchase on the grounds that nothing which had been used in a real ceremony should become a stage prop. (This same group has met with criticism because, "No way should a guy get to wear a chief's *gwiis gan m'ala* unless he's put up the feast, put up the money.") However, Marion Hunt Doig's father, Thomas Hunt, advised her, "It's all right, Marion, for you to educate people about our things because they're just going to disappear if you don't." So Marion wears her robe and teaches with great success.

Does the growth of similar teaching situations, coupled with the growth of the dance groups, imply that the majority of Indian people support the educational usages? Support them as cultural bridges for Indian children to their past and as bridges to outsiders, many of whom misunderstand the Indian heritage or are unaware of its stature? Or is the growth diluting the heritage? Should the robes remain as visual testaments to membership in exclusive lodges whose passwords and optic signals are known to few? Does exclusiveness augment sense of worth? Does exclusiveness enhance spirituality?

What was the source of inspiration for the button robes? Have different types different origins? Were some fashioned with naval officers' uniforms in mind? Lathum (1977) states that all European navies wore dark blue after 1865 except the Russian, which wore green, then blue. The Sunday uniform of the British midshipman was not only navy blue, but also had two rows of white pearl buttons as decoration. Are the robes' borders and buttons reminiscent of officers' lapels with their nearby buttons?

Was a clerical robe the Tahltan prototype? The Tahltan "humpback" could be the descendant of a monk's hood ('Ksan), or represent the shelter over a communal house's smoke hole, or a sailor's middy collar, or the rain-protective, double-layered back of a trench coat, or...?

Did a Tsimshian designer create semi-ready, crest-type robes for export, a possibility that Martha Brown's "blanket kits" suggests?

When did the button robe take over from the capes of fur and hide? The literature supplies no positive answer, but European textiles were in demand from an early date, particularly those of red or blue hue. Perez (1774) found cloth an acceptable gift. La Pérouse (1786) took possession of land at Letua Bay for "several yards of red cloth, hatchets, adzes, bar iron and nails" (Pethick 1976: 104). "Chief Seax (1789) offered Colnett his clothes in exchange for a coat of European cloth" (Moeller 1966: 15). In 1792, Caamano made several telling statements:

> These Indians seemed anxious chiefly to obtain cloth of serge or baize or other material that might serve for protective covering (p. 202). A few wear coats or pieces of blue cloth, and even old English uniforms, as the English and more especially the Americans, give anything they have … in exchange for the skins of the sea otter (p. 273). He wore a long, blue cloth overcoat reaching to his heels, surmounted by a cloak of similar material and colour, such as is usually worn by them. This cloak was trimmed with an edging five or six inches wide, painted with various figures and grotesque faces, made of deer skin (p. 272).

In 1793, before Alexander MacKenzie reached the coast, he met at Friendly Village in the Interior a chief who "produced ... a garment of blue cloth trimmed with brass buttons and one of flowered cotton fringed in the Spanish manner" (Ormsby 1958: 32). In the same year, at Nootka, when the great Maquinna entertained Vancouver, "The whole royal family was dressed in British woollens" (Gunther 1966: 73).

According to Codere, "The process of substituting woollen blankets for those of fur and cedar bark started with the first known contact with the Kwakiutl on the occasion of Vancouver's stop at the Nimpkish village just opposite the present location of Alert Bay. Menzies writes, 'The articles they most esteemed were sheet copper and coarse broad blue cloth ... a piece about the square of the cloth for a skin' " (Codere 1950: 95).

By 1846, the fur trade on the coast was abandoned because the sea otters were hunted out. In one year, 1802, the United States and Russia alone sold 25,000 otter pelts (Howay 1944: 20). Had the chiefs wished to retain their otter robes, the wish would have been beyond fulfilment. The obvious substitute was a good-quality wool blanket. As David Gladstone points out, the transition was from "wearing blankets all the time to wearing clothes and wearing blankets for dress."

Photographs and drawings of seemingly transitional robes show combinations of blanket cloth with painted leather borders, with fur borders, Chilkat borders, dentalia design and no border, and with panels of buttons and no appliqué or border. It is probable that the dentalia-only and buttons-only types preceded the modes using appliqué plus dentalia or buttons, possibly because shell "buttons" decorated chiefly apparel prior to the advent of imported textiles or buttons.

Bill Holm claims (1983: 61) that the robe "probably reached its classic form around 1850 although no solid documentation is available for that time." For the present, Moses Ingram's explanation that the button blanket "just came naturally" is as conclusive as anything the team discovered.

Has the classic form hidden meanings? Are there subtle messages in its shape, its colours, its borders, its buttons?

Is navy blue the successor to the "deep blue" which Flossie Lambly describes and early explorers such as Meares and Caamano frequently mention: "He was wearing the blue robes chiefs

wear" (Wagner 1938: 292)? Did that colour denote some special magic, meaning, or power? Blue has a spiritual significance among many Indian groups throughout the continent, throughout the world. Has the navy blanket that kind of message?

Several people asked why the robe's basic colour is navy rather than black, Northwest Coast Indian art's dominant colour. Did the community look upon navy and black as one because the same word designated both colours? In at least one Indian language, the same word is used for any dark colour except brown.

What is the meaning or purpose of the red borders? Are they purely ornamental? Are they the descendants of the red ochre that coloured the bodies and hands of those who met the early explorers and traders?[3] Has red a spiritual significance, as Martine Reid records (p. 76)? Is this spirituality the source of the great value the *halayt* placed on red *mas* (Sophie Mowatt, p. 74)? Does red signify blood and therefore life (Sophia Mowatt)? Does red, by virtue of its spiritual significance, imply power, and hence protection and security? Is that why red is used as a warning to trespassers? Did the robe's designer(s) compose a many-faceted visual pun—a house that protects and strengthens the House by the power implicit in the colour of its frame? Perhaps red means all these things, and more.

Were the red and the blue "to remind people that the same [devastation] could happen again; they should always look after the land because the land was not theirs but on loan to them" (Norman Tait)?

What is the purpose of the white pearl buttons which grace every type of ceremonial button robe? Do the buttons share the peace-ensuring power of white eagle down, the "soft voice that none may ignore" ('Ksan files)? White, to quote David Gladstone, "meant ... you were of peaceful intention and that you weren't going to use harmful magic." Do white buttons imply purity of character, a prerequisite for a name? Are the buttons replacements for the white dentalia which, photographs indicate, preceded the buttons and red appliqué, or did the Cockney Pearlies set the button mode, as Daisy Sewid Smith suggests (p. 63)?

Does the word "blanket" do justice to the robes? Francis Williams voices this concern: "I don't like to call them blankets. They are worn like a king wears his robe." 'Ksan's Book Builders address the same problem. Perhaps one of their suggestions will fit the mindset of other groups. Somewhere, in someone's head, the perfect English translation is waiting.

Should the symbols on a crest-type ceremonial robe be called "designs?" Does "design" belittle that blazoning of ancient achievement, that confirmation of present status? Dempsey Bob says, "When we wear our blankets, we show our face. We show who we are and where we come from." Others make similar statements. Does "design" voice that type of thought?

Who is more important—the designer, or the person who sews the robe? The team found themselves confronting the question, "If the design's good, does it matter who does the sewing?" For once, the team will hazard an answer: "It does." Those who have worked closely with blanket makers have seen good designs ruined by poor sewing, and vice versa. By careful placing of buttons, subtle adjustments of line, even the elimination of certain elements, a good needleperson can work wonders with a fairly ordinary design. The person who sews the robe makes the final decisions. A poor sewer can turn well designed ovoids and u-forms[4] into jelly-beans and worms. The only conclusion must be that designer and maker are equally important.

How is the code deciphered? How does a person learn to read the "eye art" language? Fortunately, several helpful books have been published,

among them Franz Boas's *Primitive Art*, Bill Holm's *Northwest Coast Indian Art*, and Hilary Stewart's *Looking at Indian Art of the Northwest Coast*. Unfortunately, a Killerwhale's fin, which the books will tell you how to distinguish, isn't simply a Killerwhale's fin. One with "the circle and dot on the dorsal fin is Mary Bell's signature ... the Killerwhale with an extra-high dorsal fin is our Haida crest," Hazel Simeon explains. As Dempsey Bob sees it, "In order to interpret the designs, you have to know the stories—family histories, yourself, your people, and nature." In the button robe's heyday, designer, wearer, and reader fully understood the fine points. The ravages of disease and the sixty-year duration of the potlatch ban blurred or completely erased parts of the visual language. The miracle is that so much remains.

What is the colourful robe's future? Should the robes come out of the museums, storage boxes, and elite command performances and play a new role as today's Indian invitation bearers, inviting the discerning to enjoy Northwest Coast Indian art at first hand? To own and view the robes as "objects of bright pride" (Reid 1967)?

If so, should an Indian artist use the hereditary crests of his House, his corporate family, or should new symbols evolve such as the *Halila* of Ken Mowatt's robe (p. 15) and Dempsey Bob's illustration of another episode from the Raven stories of the Northwest Coast? Would renewed vitality emerge if new "pictographs" with their appropriate stories became part of today's Indian art? Is anyone going to take the button blanket, "that large blank sheet of paper" David Gladstone praises, and make it tell of new adventures with a new kind of power? Or do these objectives negate the robe's traditional role?

Further research must be done: the hunt should proceed, though it is seventy or eighty years late and would have been more successful when the true laws were clear in many minds, not dimmed through disuse.

Careful analysis of ceremonial button robes in museum collections and elsewhere should provide some positive answers, especially if the status of the name to which a given piece belonged can be determined. Access to all known records of early explorers and traders should chart more clearly the robe's transition from hide and fur to the stately Tahltan and stunning crest-type robe.

A full list of the possibilities and questions could exhaust this book's printing budget, but one more question must be risked: who will take over where **Robes of Power** leaves off?

[1] A sixty-year period beginning in 1884.
[2] 'Ksan, Hazelton, B.C.
[3] Crespi, Vancouver, Caamano and others.
[4] Terms used by Bill Holm in *Northwest Coast Indian Art*.

Bibliography

Allen, Max. *The Birth Symbol in Traditional Women's Art from Eurasia and the Western Pacific.* Toronto: The Museum for Textiles, 1981.

Barbeau, Marius. *The Downfall of Temlahan.* Edmonton: Hurtig Publishers, 1973.

Barbeau, Marius. *Totem Poles of the Gitksan, Upper Skeena River B.C.* Anthropological Series No. 12, Bulletin No. 61. Ottawa, 1929.

Beaglehole, J.C. (ed.). *The Journals of Captain James Cook on His Voyage of Discovery 1776-1780.* Cambridge University Press, 1967.

Blackman, Margaret B. *During My Time.* Seattle: University of Washington Press, 1982.

Boas, Franz. *Primitive Art.* New York: Dover Publications, 1955.

Caamano, Jacinto. "The Journal of Jacinto Caamano. Translated by Captain Harold Grenfell, R.N. Edited by Henry R. Wagner and W.A. Newcombe." *B.C. Historical Quarterly*, vol. 2. Victoria: Archives of B.C., 1938, 189-301.

Codère, Helen. *Fighting with Property.* New York: J.J. Augustin, 1950.

Cosgrove-Smith, Patricia. *Innovations for a Changing Time. Willie Seaweed: A Master Kwakiutl Artist.* Seattle: Pacific Science Centre, 1983.

Davis, Pat. "A Comparative Analysis of Button Blankets." Unpublished research paper, University of Washington, Seattle.

deLaguna, Frederica. *Under Mount Saint Elias: The History and Culture of the Yakutat Tlinget.* Smithsonian Contribution to Anthropology, vol. 7 (3 parts). Washington, D.C.: Smithsonian Institution Press, 1972.

Drucker, Philip. *Indians of the Northwest Coast.* New York: Natural History Press, 1955.

Duff, Wilson. *The Indian History of British Columbia. Vol. 1: The Impact of the White Man.* Anthropology in British Columbia, Memoir 5. Victoria, B.C.: B.C. Provincial Museum.

Garfield, Viola Edmundson. *The Tsimshian Indians and their Arts: The Tsimshian and their Neighbours.* Seattle: University of Washington Press, 1979.

Gunther, Erna. *Art in the Life of the Northwest Coast Indians.* Portland, Oregon: Portland Art Museum, 1966.

Hanson, Charles E. "The Point Blanket." *Museum of the Fur Trade Quarterly*, Vol. 12, No. 1, 1976, 5-10.

Harris, Chief Kenneth B. *Visitors Who Never Left.* Vancouver: University of British Columbia Press, 1974.

Hawthorn, Audrey. *Kwakiutl Art.* Seattle: University of Washington Press, 1979.

Holm, Bill. *Northwest Coast Indian Art.* Seattle: University of Washington Press, 1965.

Holm, Bill. *The Box of Daylight*. Seattle Art Museum. Seattle and London: University of Washington Press, 1983.

Howay, Frederick William. "William Sturgess: The Northwest Fur Trade." *The B.C. Historical Quarterly*, Vol. 8, No. 1 (1944).

Latham, R. Wilkinson. *The Royal Navy 1790—1970*. Osprey Publishing, 1977.

MacDonald, George F. *The Totem Poles and Monuments of Gitwagak Village*. Hull, Quebec: Canadian Government Publishing Centre, 1984.

MacDonald, George F. *Ninstints*. UBC Museum of Anthropology Museum Note No. 12. Vancouver: University of British Columbia Press, 1983.

Miller, Jay and Carol M. Eastman. *The Tsimshian and Their Neighbors of the North Pacific Coast*. Seattle: University of Washington Press, 1984.

Moeller, Beverly B. "Captain James Colnett and the Tsimshian Indians, 1797." *Pacific Northwest Quarterly*, Vol. 57, No. 1, 13-17.

Niblack, Ensign Albert P. *The Coast Indians of Southern Alaska and North British Columbia*. Washington, 1890.

Northwest Coast Indian Artists Guild 1977. Ottawa: Canadian Indian Marketing Services, 1977.

Otness, Sharol Lind. "The Tlingit Button Blanket." Unpublished paper presented at the Oregon State University, Portland, as part of a master's thesis course, 1979.

Ormsby, Margaret A. *British Columbia: A History*. Toronto: Macmillan, 1958.

Pethick, Derrick. *First Approaches to the Northwest Coast*. Vancouver: J.J. Douglas, 1976.

Reid, Bill. "The Art—An Appreciation." *Arts of the Raven*, Vancouver Art Gallery, 1967.

Samuel, Cheryl. *The Chilkat Dancing Blanket*. Seattle: Pacific Search Press, 1982.

Seguin, Margaret. *The Tsimshian: Images of the Past, Views of the Present*. Vancouver: University of British Columbia Press, 1984.

Tedds, Dee. "An Analysis of Button Blankets From the Northwest Coast." Unpublished anthropology research paper, Carlton University, Ottawa, 1981.

Wagner, Henry R. and W.A. Newcombe. "The Journal of Jacinto Caamano." *B.C. Historical Quarterly*, Vol. 2, 1938.

Acknowledgements

It is with a happy heart that I express my sincere gratitude to the many individuals whose interest and assistance made it possible for the story to be told about button blankets, the robes of power.

To *N'ii Kap'*, hereditary Gitksan Chief David Gunanoot, whose words about button blankets inspired the phrase, "robes of power"; Sue Ann Sargent, who encouraged me to do this book, for her continued support and assistance; Peggy Martin, who, on several occasions, pitched in and helped when I needed it, for her continued enthusiasm and support; Dee Tedds, for tracking down the Menisqu' robe; Margaret Blackman, for giving me her valuable research material on button blankets; Richard Inglis, for reading parts of the first draft of the manuscript and providing constructive criticism and research material, and Richard again, together with Sandy Kieland, Emma Beans and her family, Agnes Cranmer, Roy and Monica Vickers, Sherry Hunt, Carrie Weir, Pearl Parsons, and Freda Diesing, for the warm hospitality that was extended to us when we were out in the "field."

To Dorothy Grant, for photographing the button-blanket collection at the Royal Ontario Museum; Alexis MacDonald, for providing her photographic talent, and in memory of her mother, Blanche, who encouraged us and reaffirmed the importance of what we were doing; Glen Wood and Lawrence Paul, who assisted Alexis with photographing the contemporary button blankets; Milton McDougal, who took over the photographic work on short notice when Alexis was unable to continue due to her mother's illness; Lee Anne Cameron, Lia Grundle, Rose Carson, Rosemary Wilson Hart, and Dolly Watts, for their support and enthusiasm, and Sally Hindle, Sarah Marshall, Bill Reid, Doug Cranmer, Bill Hunt, Mrs. James Knox, Fred Johnson, and David Milton, for allowing me to interview them about button blankets.

For invaluable letters of support: George MacDonald, Director, National Museum of Man, Ottawa; Marjorie Halpin, Curator of Ethnology, UBC Museum of Anthropology, Vancouver; Cheryl Brooks, Native Programs, Department of the Secretary of State, Vancouver; Neil J. Sterritt, President, Gitksan Wetsuetin Tribal Council, Hazelton; Mr. Jean Rivard, Director, Vancouver Indian Centre, Vancouver, and Shirley Joseph, President, Professional Native Women's Association, Vancouver.

To the Indian Arts and Crafts Society of B.C., President Noll Derriksan and his board of directors, who agreed to sponsor and support the project, and to the society's staff, particularly Myrtle Cosky, for transcribing and typing the taped interviews and the first draft of the manuscript.

To the button-blanket makers and their families, who opened their hearts, their homes, and their memory banks to me, and allowed me to record their family histories about button blankets so that others will have an opportunity to appreciate the blankets' beauty and understand their important message.

The staff of museums and other institutions contributed much by allowing me to examine and photograph collections of early button blankets and by searching out early accession data: Peter Macnair, Curator of Ethnology, and Dan Savard, Photo Archivist, B.C. Provincial Museum,

Victoria; Bill Holm, then Curator of Northwest Coast Indian Art, Burke Museum, University of Washington, Seattle; Gerald McMaster, Curator of Contemporary Indian Art, and Leslie Tepper, National Museum of Man, Ottawa; Eve Hope, Curator, the Northwestern National Exhibition Centre, Hazelton; Valerie Grant, Curator, Royal Ontario Museum, Toronto; Donald Jenkins, Director and Jean Harrison, Curatorial Assistant, Portland Art Museum, Oregon; Elizabeth Johnson, Curator of Collections, Madeline Rowan, Curator of Ethnology, Herb Watson and Beth Carter for exhibit design, UBC Museum of Anthropology, Vancouver; Ron Denman, then Director, Museum of Northern B.C., Prince Rupert; the Museum of Anthropology, Budapest, Hungary; Zoe Wakelin-King, anthropologist, Australia Museum, Sydney; H. Thomas Cain, anthropologist, Heard Museum, Phoenix, Arizona; Patrick Houlihan, Director, Southwest Museum, Los Angeles, California; David Stone, Assistant Curator, Alberni Valley Museum, Port Alberni; Trisha Gessler, Curator, Queen Charlotte Islands Museum, Skidegate; Thomas Vaughn, Oregon Historical Society, Portland, and Peggy Martin, Vancouver Museum.

To Polly Sargent, who set aside some of her priorities to work with me for nearly two years, and to Jean McLaughlin, for her hard work and commitment throughout the project.

Special thanks to my family for their love and support: to my husband, Vergil Jensen; my children, Valerie, Richard, Michael and his wife Sue, Cindy and her husband Darrell; my sisters, Thelma Blackstock, Margaret Heit, Barbara Sennott, Jean Harris, and my brother, Walter Harris. To my mother, Clara Harris, who was a constant source of guidance, and to the memory of my father, Chris Harris, who first introduced me to button blankets and the important role they play in recording family and clan history.

Photographic Credits

Adelaide Festival Centre: Plate XIX.
British Columbia Provincial Museum: Figures 4, 37, 38, 39, 40, 41, 42.
British Museum: Figure 36.
Canadian Museum of Civilization: endpapers, H. Foster; figure 33.
David Gladstone: Figures 27, 28, 29.
Bill Holm: Figure 3.
Vickie Jensen: Plate IV.
Virginia Kimmett: Figure 7.
Alexis MacDonald: Figures 1, 2, 8, 9, 10, 11, 12, 14, 15, 20, 21, 22, 23, 25, 26, 30, 31, 35.
Alexis MacDonald and Paul Litherland: Plates I, II, III, V, VI, VII, IX, X, XI, XII, XIII, XIV, XV, XVI, XVII, XVIII, XX.
Milton McDougal: Figures 6, 13, 17, 18, 19, 24, 34.
Royal Ontario Museum: Cover, figure 5.
UBC Museum of Anthropology: Plates XXI, XXIII and figures 16, 32, M. Cotic; plates XXII, XXIV, XXV, J.L. Gijssen.
Don Waite: Plate VIII.